A Female Focus

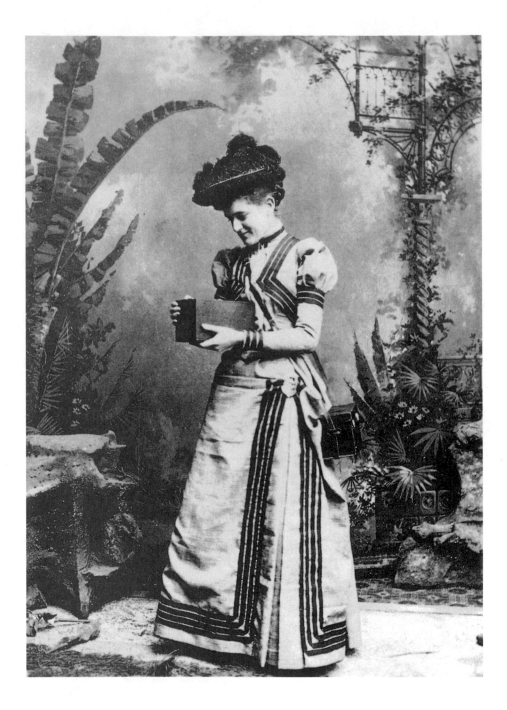

A Female Focus

GREAT WOMEN PHOTOGRAPHERS

MARGOT F. HORWITZ

Women Then—Women Now

Franklin Watts
A Division of Grolier Publishing
New York London Hong Kong Sydney
Danbury, Connecticut

To

Ellis Horwitz, my favorite photographer,
and our children, Claudia and Stuart,
for their loving and literate support

Frontispiece: Woman with Kodak box camera in the 1890s

Photographs ©: Courtesy of Amon Carter Museum, Fort Worth, Texas: 34 (Fred E. Mang, Jr.); The Bettmann Archive: 2; Brigette Lacombe: 94; David Seidner: 106; Edwina Harleston Whitlock: 42; The Imogen Cunningham Trust: cover, Collection of the J. Paul Getty Museum, Malibu, California: 44 (Man Ray), 12 (William Henry Fox Talbot); Julie Weisz: 84; Magnum Photos: 76 (Eve Arnold); Mark Morosse: 88; Ronald Partridge: chapter openers, 53; Smithsonian Institution: 25, 30; Estate of Diane Arbus/Stephen Frank: 82; Doris Ulmann Collection, CN7677, Special Collections, University of Oregon Library: 33 (John Jacob Niles); UPI/Corbis-Bettmann: 64.

Insert photographs ©: Library of Congress: 1; George Eastman House: 2; Library of Congress: 3; The Metropolitan Museum of Art, Alfred Stieglitz Collection: 4; Collection of the J. Paul Getty Museum, Malibu, California: 5 bottom; Library of Congress: 5 top; Courtesy of Amon Carter Museum, Fort Worth, Texas: 6 top; The Imogen Cunningham Trust: 6 bottom, 7; Commerce Graphics Ltd., Inc.: 8 bottom; Edwina Harleston Whitlock: 8 top; Library of Congress: 9; Courtesy Fashion Institute of Technology: 10; Collection of the J. Paul Getty Museum, Malibu, California: 11 bottom; Life Magazine © Time Inc.: 11 top; Estate of Diane Arbus/Courtesy Robert Miller Gallery, New York: 12 bottom; Magnum Photos: 12 top; Judy Dater: 13; Jeanne Moutoussamy-Ashe: 14 top; Mary Ellen Mark: 14 bottom; Cindy Sherman: 16.

Library of Congress Cataloging-in-Publication Data

Horwitz, Margot F.
 A female focus : great women photographers / Margot F. Horwitz.
 p. cm. — (Women then—women now)
 Includes index.
 Summary: Surveys the work of American women photographers over the past 150 years, examining what they photographed and why, as well as how they worked.
 ISBN 0-531-11302-7 (lib.bdg.) ISBN 0-531-15830-6 (pbk.)
 1. Women photographers—United States—History—Juvenile literature. 2. Photography—United States—History—Juvenile literature.
[1. Photographers. 2. Photography—History. 3. Women—Biography.]
I. Title. II. Series.
TR23.H67 1996
770'.92'273—dc20 96-14600 CIP AC
[B]

Contents

Chapter One

Opening the Lens

"**W**omen have used their intelligence, energy, concern, and dedicated purposefulness to give us large and small insights into the broad human picture."[1]

These words were written in 1975 by curator John Humphrey in his introduction to *Women of Photography: An Historical Survey.* His judgment accurately describes the significant role women have played throughout the almost two-centuries-old history of photography.

Photography—a combination of lens, a shutter, illumination, and a flat surface coated with chemicals sensitive to light—was invented in the early 1800s by people looking for an exact and lasting record of their surroundings. With this new technique (or combinations of techniques), they produced in a short time images that were more real and detailed than painters could produce in weeks and months of effort.

Photography's capacity for rapid communication became even more significant as industrial technology

expanded the boundaries of artistic expression. When a series of inventions in the late 1800s made photography both physically and financially manageable, American women in large numbers joined men in the art.

For a long time, however, their participation was largely ignored. Until recently, photographic histories have slighted women's efforts and put aside their significant contributions to the development of the medium. Museums, in the past, have also lagged behind in both the collection and exhibition of women's photographic work.

The truth is that from the earliest days of photography, women have earned a living or found unpaid creative expression by making portraits of their families, friends, and clients. Women have continued to make a name in portraiture, of celebrities and ordinary people, as well as in photojournalism, advertising, fashion, and fine art. Indeed, women photographers have had long careers exhibiting, teaching, and writing and have often achieved a high degree of success and recognition.

Nevertheless, women photographers striving to make their mark have often encountered obstacles along the way. Some talented women had to place family responsibilities above artistic involvement; others faced discrimination of all kinds in the workplace. As in other professions, many women photographers have had to work harder than men for the recognition they finally received. These social and economic barriers, according to art historian Anne Tucker, "drain their energy and, through the anger provoked, cripple their talent."[2]

The story of women photographers with its triumphs and troubles must be viewed through the prism of world history, with its often drastic disturbance of life patterns. When World War II demanded the active service of all able-bodied men (and many women), females at home were often pressed into other kinds of action. In a 1943

issue of *Popular Photography*, photographer Constance Bannister wrote that women had to put aside their work in such fields as photography because they were too busy "doing other things (having babies, nursing soldiers, driving trucks, building tanks, teaching school), doing all of the other million odd jobs which keep a country rolling."[3] Those tasks kept women from appreciating the value of their professional and artistic contributions.

Bannister had confidence in her own skills, but she also had well-founded concern about prejudice against professional women. When the Associated Press in Miami hired her, male colleagues put harmful chemicals in her developing fluid, scratched her negatives, and offered to "fix" her camera before she went off on assignments they wanted. She was soon forced to develop her negatives in hotel bathrooms to avoid such incidents.

A Female Focus: Great Women Photographers traces the still-unfolding history of women photographers, from the pioneers, working with the most primitive of processes, to today's artists, who make exceptional use of technological improvements. It also covers the dramatic and significant world events that have been captured by women photographers. From scenes of children forced into labor after the Industrial Revolution to migrant workers' struggles to eke out a living during the Great Depression to women's and minorities' strivings for identity, female photographers have been there. They also have been on hand to witness wars and famine, the beauty of nature, and the joy of family life.

An analysis of women photographers generates a number of questions. Which artists, impelled by a sense of privacy, revealed little of their personal lives in their work, and which seemed close and open to their subjects? Why, even in modern times, did some decide to

9

photograph close to home while others continually traveled the globe? What prompted bizarre, almost inexplicable images by some, and highly traditional work by others? And why did some of the photographers marry and have families while others chose to remain single, or at least to delay their careers until their children were raised?

A Female Focus: Great Women Photographers describes the efforts of women during different periods of world history—how they responded to the political and social tenor of the times and how they contributed to the evolving artistic atmosphere. The book also attempts to understand the reasons behind what and how they photographed as a reflection of their individual viewpoints, lifestyles, and reactions to the world around them.

While this book necessarily passes over many women artists to give a balanced historical overview, it strives to place a well-earned spotlight on the achievements of women of many cultures. With their unique backgrounds and special skills, all of the women described have played a part in making photography the significant art it is today.

It is exciting to see how so many generations of women have captured their unique perceptions of reality and passed them along—to be accepted or rejected by the general public and younger practitioners of the art. Whether the photographers clung to tradition or ran from it, their vital, ongoing legacy is an expression of the humor, anger, sadness, whimsy, and joy that are part of human life.

Chapter Two

Pioneers: The First Women Photographers

Probably the first known woman photographer—and photographic technician—was Constance Talbot, an Englishwoman married to an inventor of the art. Although Constance Talbot often joined her husband in his picture-taking activities in the mid-1830s, and sometimes made her own exposures and prints, she was ignored in most historical accounts of early photography. It is a sign of those times that women were assumed to have played only supporting roles in joint endeavors.

The first photograph was made in 1826 by French chemist Joseph N. Niepce, who exposed a coated pewter plate in a camera to sunlight for about eight hours. Niepce formed a partnership with another Frenchman, Louis J. M. Daguerre, and the two men invented a technique for making positive images directly on metal plates. In 1839, Daguerre introduced a method using metal plates coated with silver iodide that produced unique, mirrorlike images with an amazing degree of precision. Photographs made by this process were

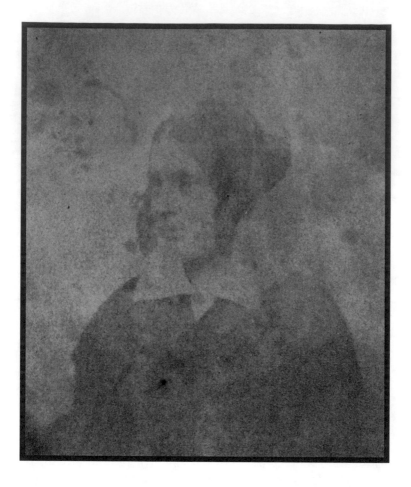

Constance Talbot in 1841

called daguerreotypes, and became very popular in the 1840s.

At about the same time the daguerreotype process was introduced, the forerunner of modern photographic film—the paper-based negative calotype process—was being developed by Constance Talbot's husband,

William H. Fox Talbot. Talbot's process created paper negatives from which positive prints could be made; it became the basis for almost all photography that followed.

The technique of recording a particular image at an instant in time spread quickly to the United States and gained immediate popularity. With increasing demand by the rising middle class for inexpensive illustrations—especially portraits of themselves and their families and friends—a market quickly developed, particularly for the daguerreotype.

Some men and women photographers worked to create elegant portraits of the upper classes, but most daguerreotypists recorded average citizens and moments in their daily lives. They had found in photography a vital means of communication and expression. Nevertheless, women working in the field of photography received little support from their male counterparts, one of whom wrote that "female Daguerreians are out of place, pants or no pants."[1]

As early as the late 1850s, certain photography journals and other publications encouraged women to enter the field. However, most women photographers of the time, like Constance Talbot, started out as assistants to photographer husbands before they went on to produce their own work. The women who were frequently appointed to do cosmetic work on the photographs, adding color to the eyes, face, and clothing, and gold paint to the jewelry, were also most often assistants in their families' daguerreotype studios.

As photographic technology gradually improved with the development of the wet-collodion process, which produced a sharp image at low cost, women began to work more often on their own. The process was called "wet-plate" because the glass plate had to be exposed and processed while damp, and it required

cumbersome portable darkroom equipment. Yet because the new system offered the best chance to make a living, women mastered the technology, and continued to do portraits.

..

SEARCHING FOR WORK

The early American women employed in the field of photography were an enterprising group. Boston native Sarah Holcomb traveled, equipment in hand, to find business, despite the hazards of bad New England weather and ruined chemicals. Photographer, retoucher, and portrait painter Julie Wittgens placed an advertisement in a local newspaper in 1858 in an effort to find photographic work. A contemporary of Wittgens's, Eliza Withington, set up a studio in a mining town in California, where she made images of the town, its mining operations, and the workers.

Aside from these pioneers (about whom little more is known), most women photographers worked primarily in their portrait studios. They worked rarely, if ever, outdoors and never on the battlefield. While some followed their husbands to the campgrounds of the Civil War, they did so as onlookers and chose not to use their professional skills to capture the drama that took place before their eyes. Women photographers of the time did not take this unique opportunity to use photography to document the realities of war or take sides. Many years would pass before they would make their mark in photojournalism.

The Civil War did, however, mark the entrance of African-American women into the field of photography. The earliest, Mary Warren, listed her profession in a Houston, Texas, directory as a photograph printer. Warren was a true pioneer in the field. In her book *Viewfind-*

ers: *Black Women Photographers*, Jeanne Moutoussamy-Ashe writes of Mary Warren's singularity: "She was a southern black woman, working in a profession unusual for black or white, male or female, in an unusually conservative and prejudiced part of America."[2]

A NEW MASS MARKET

A major turning point in photography came with the invention of gelatin dry plates in the 1870s. These dry plates could be commercially manufactured months before use and could be developed long after exposure. Because they didn't have to process the plates immediately, photographers had the freedom to shoot pictures almost anywhere.

At about the same time, manufacturers improved the photographic equipment. Cameras were lighter and smaller, had faster shutter speeds, and did not require tripods. These handheld wonders made instantaneous photography, or snapshots, possible. As a result of these innovations, women as well as men took up photography in large numbers for entertainment and enterprise.

In 1883, the "detective camera" was introduced, and it became very popular with the burgeoning mass amateur market. The camera allowed photographers to take as many pictures as they wished, wherever they went. Because it was compact and lightweight and attracted little attention when used, this camera was especially appealing to female photographers during the Victorian age, when women were expected not to call attention to themselves.

In 1888, George Eastman introduced the Kodak camera. The perfect amateur camera of its day, the Kodak was only 5 inches (13 cm) long, 3.5 inches (9 cm) wide, and less than 4 inches (10 cm) high. The

camera's manual had the briefest of instructions. Eastman's slogan was just as simple: "You press the button, we do the rest."[3]

It was finally possible for ordinary people to use a camera without worrying about focus, exposure time, and processing. Companies that sold photographic equipment like Eastman (later Eastman-Kodak) began to advertise to a new mass market of consumers, which included women.

At the same time, the roles of middle-class women were in the midst of change. Greater educational opportunities, plentiful household domestic help, and the invention of such simple laborsaving devices as canned food enabled many middle-class women to move beyond their domestic responsibilities and allowed many to take up photography. Soon these amateur photographers became accomplished professionals.

A FIELD OF HER OWN

One leading woman photographer of the late 1800s was Frances Benjamin Johnston, who started her career as a correspondent for a New York magazine. She first illustrated her articles with drawings but soon decided that photographs would be more interesting to the public. Given her first camera by friend George Eastman, she produced the article "Uncle Sam's Money" and illustrated it with her photographs. This forthright exploration of taxes began her career in family magazines.

Johnston typified the public's view of a "new woman." One of her most famous photographs is a satirical self-portrait that shows her smoking, drinking beer, and—most shocking of all—revealing her (stockinged) legs.

Although that lighthearted photograph is one of the artist's enduring images, Johnston also developed a reputation for more sober work. She captured on film the

hard life of the people who worked in coal mines and cigar-box and shoe factories. Johnston's detailed documentation of the difficulties that industrial workers faced in America in the late 1800s was a model for the photojournalists that came after.

Frances Benjamin Johnston became one of America's most successful professional photographers. Her work caught the eye of government leaders, and she was invited to the White House to photograph the families of many presidents, including those of Grover Cleveland, Benjamin Harrison, William McKinley, Theodore Roosevelt, and William Howard Taft. Her pictures of first ladies were particularly popular and appeared in magazines.

During the late 1800s, educator and political leader Booker T. Washington commissioned Johnston to take photographs of two major black colleges, Hampton and Tuskegee universities. One might wonder why Washington, an advocate for black business, would hire a white photographer, no matter how proficient or well connected.

While acknowledging the publicity value—more attention would have been paid to Johnston's work than to that of a black photographer—Jeanne Moutoussamy-Ashe regrets the lost opportunity for such a plum assignment:

> The unfortunate fact that a black photographer was not given the opportunity for the assignment only reinforces just how difficult a situation black male and female photographers faced as they pursued success and acceptance in photographic history.[4]

Through her success—and desire to make photography a positive experience for women—Frances Benjamin Johnston became the center of a large, informal

17

network of women photographers. She was a counselor, friend, and critic to many amateur and professional women photographers. As photographer, journalist, and lecturer, Johnston generously helped women learn the new technology and advance their creative abilities.

..

FROM HOBBY TO CAREER

Another woman photographer of the late 1800s, Catharine Barnes Ward studied art at Vassar College, in Poughkeepsie, New York, but she had to drop out to run her family's home after her mother died. Before long, however, she found herself able to integrate family chores with her hobby of photography. The hobby soon became her life's work.

Working first in her home and then in a separate building, Barnes Ward created a custom-built, state-of-the-art studio. It cost seven thousand dollars—then a staggering sum of money—plus the price of equipment and supplies, but Barnes Ward made good use of it. The young photographer did all of her work there, including posing her subjects, lighting, developing, and printing.

Barred from membership in an all-male photography society in her native Albany, New York, Barnes Ward applied for and was granted membership in the Society of Amateur Photographers in New York City. Ultimately, she maintained memberships in many such societies and became an editor of *American Amateur Photographer*. Through her work and writing, Barnes Ward made clear that photography was a serious pursuit.

Catharine Barnes Ward was quite determined on the subject of equal rights for women in her field. In 1884, in an article published in *American Amateur Photographer*, she wrote about rights for women: "Every woman, like every man in this country, should have a means of

earning a living."[5] Like Frances Benjamin Johnston, Barnes Ward was a strong supporter of other women in the field.

As a woman photographer, Catharine Barnes Ward did not ask for special treatment. She condemned some photography societies' practice of assigning lower membership fees for women photographers: "Good work is good work, whether it be by a man or a woman, and poor is poor by the same rules."[6] On her own photography expeditions, she insisted on carrying her own equipment, which included her bulky 8 x 10 camera, lenses, and double plate holders. She also argued that women photographers should put aside fashion concerns and wear practical clothes when working.

Before marrying British photography editor Henry Snowden Ward in 1891, Barnes Ward had established a reputation as a major force in American photography. After moving to England with her husband, she continued to lecture and write and became editor of the women's department of the English journal *Photogram*. From all accounts, marriage did not keep Catharine Barnes Ward from pursuing her goals. She seems to have had a good working relationship with her husband, who had similar professional interests.

..

ART AS PREPARATION

Johnston, Barnes Ward, and many other early women photographers working in the late 1800s had extensive art educations. The society of the time considered art an important subject for young women to study as a natural extension of their domestic role. Some women used their training to find jobs, especially in portraiture (an occupation popular with women for its flexible hours); others found it an outlet for artistic ambition. In what-

ever way they used the skill, women photographers credited their ability to understand poses, lighting, and expression to their early training in the fine arts.

One portrait photographer who started out as a painting student was Alice Boughton. In 1890, Boughton opened her own studio and remained an active photographer, mostly in portraiture, for forty years. She used a soft-focus technique and a sensitive treatment of her sitters, and wrote searchingly about portrait photography. Although Boughton used the pronoun *he* in the following quotation, she was clearly thinking about women behind the lens:

The photographer must first of all have ideas. He must understand his tools and his personality must play so prominent a part that it cannot be undervalued. He must have tact and infinite patience. The photographer should be intuitive, to be able to get in touch with his subject; to be ready when the right instant presents itself.[7]

Not all women photographers of the time, however, were trained in art schools. With little artistic background, sisters Frances and Mary Allen developed a highly successful photography business in Massachusetts. Former elementary-school teachers, they took pictures of children, local historical houses, furnishings, and crafts.

The Allens never married, though they were involved in family and domestic duties. Their photography and needlework gave them a creative outlet in a domestic lifestyle; they chose subjects from nearby, working around their domestic responsibilities, and did portraits of local sitters. They enjoyed the success of the publication of their work in books and magazines.

The Allen sisters frequently sought advice from Frances Benjamin Johnston, and Mary visited Johnston in Washington, D.C. Despite the differences between Johnston and these dedicated amateurs, who rarely ventured beyond their geographic or cultural boundaries, the three shared a mutual respect.

Frances Benjamin Johnston also helped Mattie Edwards Hewitt to make the transition from nineteenth-century amateur to twentieth-century professional. A longtime friend of Johnston's, Hewitt moved from her native St. Louis, Missouri, to join the famous photographer in a short-lived business in Washington, D.C. Later, Hewitt went on to start her own business, concentrating on photographs of home and garden.

STUDIOS FOR PORTRAITS AND MORE
There were a number of other women of that time for whom photography was the perfect medium—at least for a while. Sallie Garrity opened her first public studio in 1886 in Chicago before moving to Louisville, Kentucky, where she established a large and flourishing photography business. Garrity eventually had sixteen assistants and as many as 150 clients a day. While working at the 1893 World's Fair, she met a man whom she married. The couple moved to Los Angeles and, as is true of some of the women photographers of the 1800s, nothing more was heard from her.

Beatrice Tonneson, also from Chicago, was an example of an independent and ambitious woman who retained close family ties. At the age of twenty-two, she bought the business of a successful male photographer and, with the financial and moral support of her father, she began a professional career. Later, she established a studio in the home of her widowed sister, who became

Tonneson's business manager. With Frances Benjamin Johnston, Beatrice Tonneson served as an American delegate to the Paris Expo in 1900.

Alice Austen was similarly supported by her family in her photographic career, in Staten Island, New York. She learned the techniques from her uncles, who built a darkroom for her and gave her financial backing. She took her camera and tripod everywhere, photographing the genteel social life of picnics, parties, and musicals. Austen remained single, with a close circle of family and friends.

As women portrait photographers worked in or near home, they had built-in subject materials in their families. Children held a particular appeal during a revival of concern for their health and safety in the late 1800s, and few artists hesitated to use their own or other people's young ones to create images that would be commercially pleasing. Many of these images, including those of turn-of-the-century artist Gertrude Käsebier, are highly valued today.

The Art of the Image: Käsebier and Watson-Schütze

In the last decade of the 1800s, a group of American photographers offered the startling assertion that images made with cameras were works of art and the people who captured those images were artists. This group of photographers believed that, with cameras, they could create something that communicated emotion instead of merely recording an event.

Since these photographers considered themselves artists, they created works that resembled other types of art, such as charcoal drawings or paintings (particularly those of the Impressionists). They called their movement pictorialism.

Although some photographers sharply criticized this new school for "extremism," pictorialism's highly personal artistic expression intrigued audiences. While the burning creativity of its first wave did not ultimately endure, the movement produced photographs of artistic merit and went on to influence generations of photographers all over the world.

In the early days of pictorialism, its leaders formed a group in New York City called the Photo-Secession. Led by the brilliant photographer Alfred Stieglitz, Photo-Secession's founding membership included two women—Gertrude Käsebier and Eva Watson-Schütze. Experimenting to achieve effects then only found in prints and nonphotographic illustrations, Photo-Secession members blurred detail by softening the focus of their lenses, and added ink, pencil, charcoal, wax, and other materials to make each photograph unique.

A LEADING PORTRAIT PHOTOGRAPHER

Born in Iowa and raised in Colorado, Gertrude Käsebier became fascinated early by some of the people who would later become her subjects, including Native Americans. She did not turn to art, however, until after she had married and raised a family. In 1888, Käsebier began her career studying painting at Pratt Institute in New York City. Although she planned to become a portrait painter, she switched to photography within five years. After working with a chemist in Germany to gain technical expertise and with a portrait photographer to learn business skills, she opened a Manhattan studio in 1897.

Käsebier became known for her natural settings and poses; dramatic, direct light; and creative style. Her style was a departure from the painted backdrops and dull, flat lighting that characterized the era's commercial portrait photography. Käsebier's purpose was not to inform but to share an experience with the viewer. Attacked at first as an amateur, Käsebier was soon imitated by the same photographers who had offered the harshest criticism.

By 1900, Stieglitz was calling Käsebier "beyond dispute the leading portrait photographer of her time."[1] Stieglitz devoted the first issue of the Photo-Secession publication *Camera Work* to her photographs, and

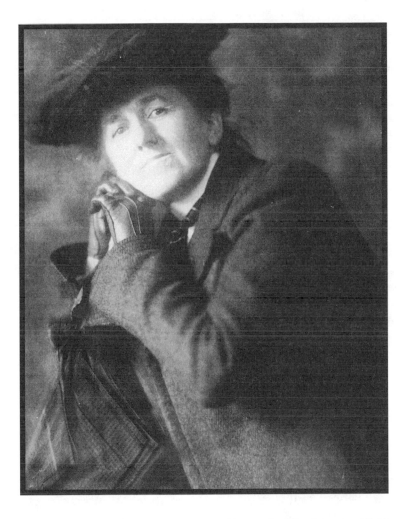

Gertrude Käsebier in 1902

placed them on exhibition at his Gallery 291. In 1912, however, Käsebier resigned from the organization when Stieglitz moved from pictorialism to straight photography.

She continued to produce pictorial images, individual commissions, and illustrations in popular journals.

In fact, she got some of those assignments from her friend Frances Benjamin Johnston. The two outspoken supporters of women photographers often sold images to the same magazines and referred jobs to each other. Käsebier, one of the most successful businesswomen of the time, worked hard to be both professionally and personally satisfied with her efforts.

CHILDREN: JOY AND BURDEN

One significant aspect of Käsebier's work is her depiction of the complex relationship between women and children. As early as 1900, Käsebier recognized the conflict between motherhood and career, between the rewards of domesticity and a desire for professional fulfillment outside the home. Käsebier experienced first-hand this dilemma that still confronts many modern women.

It is interesting to note that Käsebier's husband, Eduard, a German immigrant who became a successful shellac importer, appears to have encouraged his wife in her work. Nearly a century before the days of women's liberation, some husbands were understanding of their wives' need for self-expression.

Käsebier's photography reveals a mixed emotion toward the children she captured on film. Many of her prints show children as sweet and lovable and mothers as nurturing. Some of her other pictures, however, communicate a dissatisfaction with the limiting role of wife and mother. These images addressed a dilemma rarely discussed at that time, despite the growing numbers of working women.

In one photograph, "Road to Rome," the mother projects a yearning for independence from her domestic responsibilities. Some of Käsebier's titles, such as "Marriage: Yoked and Muzzled," clearly articulate the conflict.

Many of Käsebier's photographs, however, are testimony to her strong connection to family. Photographs like "Blessed Art Thou Among Women" and "The Manger" express protective caring. "The Manger," shown at a major salon exhibition in Philadelphia in 1900, won Käsebier critical praise for reflecting the photographer's joy in motherhood. The photograph brought the highest price ever paid for an art photograph: one hundred dollars.

An unexpected benefit of Käsebier's success was the understanding that developed between the photographer and her grown daughter after she became a mother. Käsebier said later:

> [We found a] greater intimacy. . . . Every barrier was down. We were not two women, mother and daughter, old and young, but two mothers with one feeling [who were sharing] . . . the tremendous import of motherhood.[2]

During her long career, Käsebier looked beyond the home for subjects worth capturing on film. She photographed society people, artists, and Native Americans. Käsebier explained her desire "to make likenesses that are biographies, to put into each photograph . . . temperament, soul, humanity."[3] Although her photographs of Native Americans were probably the most documentary in style of all of her work, they retained her unique touch. The special quality found in Gertrude Käsebier's photographs often happened as if by accident. She acknowledged that she would often be photographing favorite subjects when an idea would hit her. The result was anything but ordinary.

Former painting student Käsebier showed her affinity to fine artists with an unusual technique. She often printed her photographs on Japanese tissue or textured paper,

drew on the image with white chalk or charcoal, and inscribed her signature directly onto the photograph, as a painter might.

FROM PAINTING TO PHOTOGRAPHY

New Jersey native Eva Watson-Schütze studied painting and modeling in the life classes of renowned artist Thomas Eakins at the Pennsylvania Academy of the Fine Arts in Philadelphia. With a growing sense of concern about unequal treatment for women, she publicly rejected the notion of a separate display of women's photographic work in the women's pavilion of the 1893 World's Fair. Turning to the camera herself, she opened a studio in Atlantic City with a fellow student and, in 1897, opened her own business in Philadelphia.

Her work of mostly portraits, landscapes, and still lifes found immediate favor. In 1898, she exhibited six pictures in the important Philadelphia Salon, where Alfred Stieglitz was an exhibition juror, and she herself later served on a jury in 1899 and 1900. Like some other women photographers of her time, Eva Watson-Schütze wrote articles for *American Amateur Photographer*, *Camera Notes*, and later, Stieglitz's publication, *Camera Work*.

Watson-Schütze was a well-known and respected photographer when she married German-born lawyer Martin Schütze in 1901. After the couple moved to Chicago for a teaching job for Martin, Eva Watson-Schütze felt isolated from the New York art scene, especially the Photo-Secession, of which she was a founding member. (Although her work appeared in the first photographic exhibition of Stieglitz's Little Galleries of the Photo-Secession, it was not included in later shows.)

Believing in her own ability and place in the photographic world, Watson-Schütze continued to work and

created a life full of art in her new home. Her studio was highly successful, and she served on an exhibition jury at the Art Institute of Chicago. She also spent some time painting at an arts and crafts colony in Woodstock, New York.

Watson-Schütze was yet another friend of Frances Benjamin Johnston's. Johnston, who considered Watson-Schütze one of America's premier women photographers, had included Watson-Schütze's work in her exhibition of 1900–1901. The two shared an understanding of the vast artistic and commercial possibilities of the camera.

MENTORING, A CENTURY AGO

Watson-Schütze was not the only photographer to work outside of New York City. West Coast photographer Anne Brigman gained attention in the early 1900s for her images of women yearning for freedom. Today these pictures are considered symbolic of feminist ideas. At the time, however, Brigman's work was often considered merely sentimental.

During the early years of pictorialism and the Photo-Secession, Anne Brigman had a close relationship with Alfred Stieglitz. Through an intense correspondence, the two shared mutual respect, similar feelings about photography, and a dedication to work. Stieglitz also became a business mentor to Brigman, helping her get better prices for her work.

Nineteen ten was a year of dramatic change for Anne Brigman. She left her husband to chart an independent future and went to New York. There she met many of the Photo-Secession photographers and became an associate member herself. Brigman believed that Stieglitz and his colleagues represented the highest artistic standards of integrity and creativity. She was grat-

Anne Brigman

ified to be represented in the Photo-Secession exhibi-
tions and in the publication *Camera Work.*

Other photographers in the Photo-Secession appreci-
ated Brigman's mystical landscapes of the Sierra Nevada
of California. This mountain range was the setting that
most inspired her. She once described a moment there
that revealed the power of photography to her:

*One day during the gathering of a thunder storm
when the air was hot and still and a yellow light
was over everything . . . new dimensions revealed*

themselves in the visualization of the human form as a part of tree and rock. . . . [A]nd I turned full force to the medium at hand.[4]

The Photo-Secession members encouraged Brigman in her work. One of those members, who encouraged many women photographers of the day, was pictorialist Clarence White.

AN EXTRAORDINARY TEACHER

After moving to New York City to join the Photo-Secession, Clarence White taught at the Brooklyn Institute of Arts and Sciences and Columbia University. In 1914, he opened his unique School of Photography, where he encouraged new uses for photographic images in advertising, film, graphic design, and magazine journalism.

White was a particularly helpful mentor to his many female students. He hired a woman, Margaret Watkins, to teach advertising photography, which was still a relatively new field, and wrote about career opportunities for women.

Clarence White influenced an entire generation of photographers, including such future luminaries as Dorothea Lange and Margaret Bourke-White, to pursue photography both as a business and an art. His leadership in stressing the commercial potential of pictorialism, including portraiture, advanced the careers of many women photographers. In 1916 White helped to found Pictorial Photographers of America, and he encouraged women to join. Within a year, 53 of the 157 members were women.

Before Clarence White broke off from the Photo-Secession with Gertrude Käsebier in 1912, he had influenced many women including Doris Ulmann and Laura

Gilpin. Both of these women began their careers in pictorialism's soft-focus style before moving on to more dramatic, sharply etched images.

ULMANN, ROBESON, AND GILPIN

Photographer Doris Ulmann became friendly with many well-known writers and artists and frequently invited them to sit for portraits in her studio. One of the prominent personalities Ulmann captured on film was African-American singer and actor Paul Robeson. The uniquely sensual photograph was new to the pictorialist style. Ulmann also traveled to Appalachia and the South to document American rural life through photography.

Paul Robeson's wife, Eslanda Cardoza Goode Robeson, took up photography after giving up her own profession as a hospital chemist and technician. She traveled abroad as business manager for her husband's growing career, but she put her scientific training to use studying photography in London. Subsequent travels to the Soviet Union, South Africa, and China gave her the opportunity to photograph government leaders as well as ordinary people. Although Eslanda Robeson did not develop a national reputation for her own work at that time—being the wife of an international music personality overshadowed everything she did professionally— she left behind an important body of work.

Another White follower, Laura Gilpin, left New York in 1918 to return to her native western United States, planning to open a portrait studio. While her early soft-focus landscapes, portraits, and still lifes reflected the pictorial mood of the time, Laura Gilpin did not work in that style during most of her career. She soon turned to Navajo Indians as subjects. In her book *The Enduring Navaho*, Gilpin captured the spirit of their culture and intimate relationship with the land.

Doris Ulmann in 1934

Laura Gilpin in 1971

At the age of eighty-one, Gilpin made a major photographic study of the land and ruins in Arizona, traveling by jeep and airplane. Many consider Gilpin's images as important as the better-known work of Edward Weston and Ansel Adams to understanding the influence of the West on modern American photography.

There are differences of opinion as to when, why, and even if pictorialism ended. In any case, photography soon reemphasized the sharp-focus realism that had been put aside at the turn of the century. The impact of World War I and the growth of industrialization must

have made pictorialism's dreamy, soft-focus landscape seem outdated to some photographers.

Gertrude Käsebier and others of the school of pictorialism, once considered radical, lived to see themselves called unfashionable. But for other photographers, such as Imogen Cunningham, the changing times proved an impetus toward greater artistic freedom and achievement.

Chapter Four

Evolving a Sharper View: From Cunningham to Abbott

Imogen Cunningham was a woman whose career spanned probably more years than that of any known photographer—seventy-five. Cunningham's work illustrates the dramatic transition from soft-focus pictorialism to a sharpened view of the world during the early decades of the 1900s.

Cunningham's early photographs reflect not only pictorialism's appeal to the imagination but also the period's custom of using children and other subjects close to home. Her approach was similar to that of her idol Gertrude Käsebier, whose work "Blessed Art Thou Among Women" had stimulated the younger woman's interest in photography as an art form.

In 1910, Cunningham got the opportunity to meet Käsebier, who was then at the height of her career. The meeting came soon after Cunningham had returned from studying photographic chemistry in Germany to open a studio in her home city of Seattle. Käsebier's energy bolstered Cunningham, who had known her call-

ing since her teenage years, when her father built her a cold-water darkroom in a woodshed, covered with black tar paper to keep out the light.

Cunningham saw Käsebier as an inspiration both as a mother and as a portrait photographer. Cunningham herself was a professional portrait photographer when, in 1915, at the age of thirty-two, she married etcher Roi Partridge and they began a family. She soon moved with him and their babies to the San Francisco Bay area, combining the tasks of mother, housewife, and photographer. Children and gardening became apt subjects for her photography.

Cunningham's plant studies are an example of the photographer's personal expression in a new modernist style. She transformed "feminine" material—plants around her home—into abstract objects by using sharp close-ups with no indication of their surroundings. While many of the images show a contemporary approach, others are softer, revealing her pictorialist beginnings.

MOVING TOWARD THE MODERN

Cunningham's approach to the plant studies was unique for her time. One photograph, "Leaf," is interesting because it does not take the predictable "design in Mother Nature" look. Cunningham saw the plant from different angles and in dramatic, often theatrical light captured an entirely original image of an everyday thing.

Cunningham's plant studies exemplify how photography was evolving in the 1920s. It was a time when practitioners were discovering new ideas and perspectives that changed the appearance of familiar objects. Many women photographers remained interested in pictorialism, as many had been welcomed into Clarence White's egalitarian Pictorial Photographers of America.

Cunningham was one of sixty-one women contributing to the association's annual journal.

Imogen Cunningham was also a pioneer in the use of nude subjects in photography. She was probably the first woman to exhibit photographs of naked men. Undeterred by the anger of Seattle critics, she continued her work after moving to San Francisco. More often, she and her woman photographer friends posed for each other in the nude. This group included Anne Brigman and two women who would later become famous: Dorothea Lange and Louise Dahl-Wolfe.

In the San Francisco area, Cunningham became friendly with many of the day's outstanding photographers, including Edward Weston and Ansel Adams. In 1932, they formed Group f/64, named after their technique of setting lenses at small openings to give greater depth of field and a sharper image. Group f/64 was to change the direction of West Coast photography.

Members of the group realized that sharp definition of images was an increasingly popular style. They decided to champion this artistic approach, which became known as "straight" or "purist" photography. Straight photography for Cunningham meant sharp images emphasizing shape, form, and light, a style she used for the rest of her long career.

In the early 1930s, Cunningham was offered a commission by *Vanity Fair* magazine to do a series on New York City. While this opportunity proved an exciting development in her professional life, Cunningham's personal life suffered as a result of the extensive traveling she did to complete the series. She and Partridge were divorced in 1934.

..

STAR PORTRAITS

To earn a living after her divorce, Cunningham sought and accepted commercial and artistic assignments. She

began to work for magazines, helping to satisfy their readers' hunger for pictures of movie stars. Cunningham became known for portrait photography of such Hollywood celebrities as Spencer Tracy, Cary Grant, and James Cagney, whom she ironically called "ugly men." Photographing celebrities helped pay her bills, but Cunningham was more interested in capturing unusual faces. Her commitment was to the human, not the heroic or handsome.

In later years, she explained her philosophy of portraiture: "You must be able to gain an understanding at short notice and at close range of the beauties of character, intellect and spirit—so as to be able to draw out the best qualities and make them show in the face of the sitter."[1] Although their styles were different, Imogen Cunningham shared Gertrude Käsebier's need to explore her subjects' inner lives. Among the personalities that Cunningham brought to public attention were members of the 1950s and 1960s "Beat" generation, hippies, and flower children.

In her eighties, Cunningham became a celebrity, a status that sometimes overshadowed the high quality and seriousness of her work. She also taught photography to students who must have appreciated the real-life artist who happened to express herself with a camera. She continually reminded them that a long lifetime of serious effort in art can be rewarding in and of itself, regardless of financial gain.

Several films were made with and about Cunningham during her later years. One director, Ann Hershey, took four years to create the film *Never Give Up: Imogen Cunningham*. Hershey felt that Cunningham "had the actress's love . . . of drawing attention to herself through the character she played, the 'little old lady whose style always defied us to understand her completely.' "[2]

Another writer spoke of her as having the "capacity

for change we rarely expect to find in an old person. She was always meeting new people, experimenting with different approaches to her work. To her, photography was more a process than a product, a series of experiences rather than a group of finished pieces."[3]

LIFE BEGINS AFTER EIGHTY

Imogen Cunningham never wasted time, motion, material, or words in whatever she created. Into her eighties and nineties, she was still making portraits, printing almost every morning, and keeping up with the work of other photographers in her part of the world and beyond. She worked seven days a week, ten hours a day—work that gave her energy to live in the present. She lived alone by choice, and when not photographing, printing, or lecturing, she spent her time visiting friends, reading, gardening, and cooking.

In an effort to pass on all she had learned, two years before she died at the age of ninety-three, Cunningham set up the Imogen Cunningham Trust to preserve her negatives and exhibit and publish her prints.

One of the works published by the Imogen Cunningham Trust was a collection of photos called *After Ninety*. The work is a testament to the conditions of old age—a bittersweet mixture of courage, wisdom, beauty, dignity, despair, and loneliness. The book also offers the perception and honesty of an elderly artist who replied on a hospital form that requested her religious affiliation, "Haven't chosen one yet!" Until her death, Cunningham was an active and lively participant in the book's development.

In *After Ninety*, Cunningham presents straightforward studies of people at the end of their lives. Throughout her life, Cunningham was motivated not by external beauty but by the vulnerable human core of personality

and spirit. Though somewhat bitter about not having been truly "discovered" until the age of eighty, she endured long enough to live her own legend.

Imogen Cunningham shared her theory of life with her University of Washington sorority sisters in a sorority magazine article:

> A woman should find her "real work," not just work to imitate men in society. . . . [T]hough a woman gains immensely in breadth and culture through a useful profession, she also gives something—something vital and energetic. Her face may betray the lack of leisure, may possibly show the strain of the work, but I cannot see that a woman of conspicuous leisure grows old more gracefully than does her energetic and creatively active sister.[4]

PHOTOGRAPHING IN PAIRS

At the same time that Imogen Cunningham was discovering the commercial value of portraiture during the 1920s, several African-American women photographers had moved into the field with their husbands. Two of these business ventures involved Elnora and Arthur Teal in Houston, Texas, and Elise Forrest and Edwin Harleston in Charleston, South Carolina.

These two portrait studios operated differently. Elnora Teal was in charge of the studio sittings, while Arthur traveled around Texas to photograph black college communities. In the Harlestons' studio, Elise Forrest Harleston, who had taken graduate courses at Tuskegee Institute in Alabama, took photographs of the clients. Her husband, a portrait painter, would then work directly from the photograph his wife had taken, saving his clients many hours of

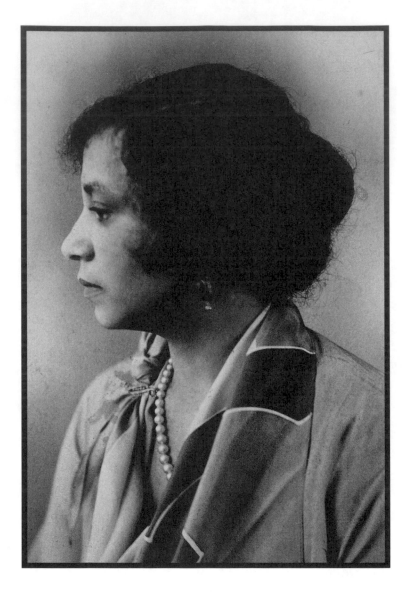

Elise Forrest Harleston

posing. Much acclaim was given to the paintings, but little mention made of Elise Harleston's photographic work.

During the 1930s, Jamaican-born Winifred Hall Allen operated a very successful portrait studio in Harlem, New York. In addition to holding private sittings in her studio, she photographed birthday parties, weddings, and club celebrations, as well as Harlem's lively street scenes. She even taught her husband, Fred Allen, the business of photography.

Husband and wife teams were a part of the photography scene since the Talbots of England in the 1830s. Many, but by no means all, of the wives in the early pairs were assistants to their husbands. Full partnerships, however, became more common in later years.

BERENICE ABBOTT AND THE IMPERSONAL PHOTOGRAPH

Berenice Abbott—a single woman—is often described as having had many lives and many photographic careers. As a young woman she moved from her native Springfield, Ohio, to Paris, seeking artistic experiences. She studied all of the arts until her money ran out, took a job as a darkroom assistant for the famous photographer Man Ray, and then left Paris for Berlin, where she spent a year studying photography.

Like Cunningham, Abbott worked taking portraits of famous people. In 1926, Abbott opened her own studio in Paris and developed a name for her unsentimental yet striking portraits of the period's leading writers and artists. Her portraits rejected the prevailing style of fantasy and formality and treated the sitters with intelligence and respect. Abbott was lauded for combining European style and American integrity in photographs of such personalities as James Joyce, André Gide, and Edna St. Vincent Millay.

Berenice Abbott in 1921

In Paris, Abbott also worked with pioneering photographer Eugene Atget, and after his death bought thousands of negatives and prints from his estate. She later sold the entire archive to the Museum of Modern Art.

In the late 1920s, Berenice Abbott returned to New York. Her commitment to photography endured. In an essay she wrote decades later, "What the Camera and I See," Berenice Abbott described photography as:

> the youngest of the Arts—young in time and dynamic in the subject matter at its command. I see the photograph as a statement of affirmation, built of wonder and curiosity. By choice of subject and special treatment given a subject, it is as personal as writing or music; while by the fact that it works with an instrument to record a segment of reality given and already made, unchangeable—it is impersonal to the highest degree. This is for me its interest; the union of the personal and the impersonal.[5]

THE CITY AS SUBJECT

The sharply focused style of Abbott's Paris portraits carried over to her photographs of New York City. Her streetscapes, sometimes called cityscapes, of lower Manhattan point up the contrasted diagonals of the bridges and verticals of the skyscrapers. Her photographs were taken at extreme angles; she often had to balance precariously on ledges and flagpoles to get the view she wanted.

Abbott was particularly interested in structures ready to be torn down and those that had just been built. At the same time, she was concerned that skyscrapers were creating man-made "canyons" that were

physically dwarfing the men who had conceived and built them.

Abbott worked for detail and clarity in her negatives, which enhanced their accuracy and realism in dramatizing New York's great scale and power. Among her most famous city subjects are the Flatiron Building, sharply outlined against a bright sky, and the spires of Trinity Church against the stark rectangular masses of office buildings. Some believe these images of New York in the 1930s are Abbott's best work. One critic described her photography as "training an unflinching eye on the severe, ironclad beauties of a great industrial metropolis . . . striking an odd balance between cultural documentation and art."[6]

Later in the 1930s, Abbott turned to the less dramatic, more poignant face of New York's changing urban environment—row houses and businesses left behind in the wake of the machine age. In capturing the street scenes—often head-on—her primary goal was to document the abstract qualities of the urban environment.

Berenice Abbott realized that documentary work required physical and mental stamina and long stretches of concentrated time, which was difficult for women with home responsibilities. Abbott also recognized that women were usually paid less than men, even for hard and dangerous jobs. Nevertheless, she encouraged women to enter the field, and expressed annoyance with promising and talented women photographers who gave up the art after marriage.

Finding paid work was a struggle for Berenice Abbott during the Depression years, which lasted through the 1930s, but she was able to support herself by teaching photography. Eventually, she secured funding from the federal Works Progress Administration to cover materials, assistants, and gas for her car. The resulting work was the outstanding book *Changing New York*.

Berenice Abbott was also a prolific writer who produced technical books and articles with practical photographic advice and suggestions for ways to improve equipment and supplies. Her 1941 *Guide to Better Photography* was an influential manual of instruction.

Abbott also experimented with scientific photography, taking photographs of soap bubbles and wave patterns. Her goal was scientific clarity, regardless of artistic result. She had considerable difficulty finding funding for these scientific projects, and always believed that men would have had far more success.

Throughout her career, Abbott had a clear sense of her goals:

The challenge for me has first been to see things as they are, whether a portrait, a city street, or a bouncing ball. In a word, I have tried to be objective. What I mean by objectivity is not the objectivity of a machine, but of a sensible human being with the mystery of personal selection at the heart of it.[7]

Berenice Abbott lived and worked through many periods of American history. Like Imogen Cunningham, she was ninety-three when she died. Intensely productive most of her life, Abbott created some of her most famous works during the Depression years, as did several other major figures of American photography.

Imogen Cunningham, Berenice Abbott, and their contemporaries moved photography along from the imaginative softness of pictorialism to the harder-edged clarity of straight photography. While there was some effort to capture American social problems—as in Abbott's photographs of run-down businesses—the use of photography to document the human condition came soon afterward.

Documenting a Troubled Nation: Lange and Dahl-Wolfe

The Great Depression, beginning with the stock market collapse of 1929, caused drastic unemployment, loss of life savings, the closing of many banks, and the foreclosure of many home mortgages. To help citizens cope during this dire economic situation, the U.S. government created a variety of special agencies.

Some of these agencies helped artists to finance their projects. Just as Berenice Abbott received a grant from the Works Progress Administration, Dorothea Lange got her big break through the national Farm Security Administration and the California State Emergency Relief Administration.

Dorothea Lange was born in 1895 in Hoboken, New Jersey. Although her family had planned a teaching career for her, all thoughts of teaching vanished after Dorothea first picked up a camera in high school. While she took some courses with the legendary Clarence White, Lange was essentially self-taught. After working in several studios in New York City, she decided to work her way around the world as a photographer.

Lange and a high school friend traveled south to New Orleans and then headed for the West Coast. In San Francisco, a pickpocket stole all of their money and Lange was forced to take a job in a photography shop. It was there that she met Imogen Cunningham and her husband, Roi Partridge, who became her lifelong friends.

Lange's time in San Francisco turned out to be a positive experience. Lange established herself as a photographer, with help from an investor who agreed to back her portrait studio. The business was an overnight success. Some of the wealthiest, most prominent families in San Francisco became her clients. In 1920 she married western painter Maynard Dixon, a friend of Roi Partridge's, and they had two sons.

After the birth of her children, Lange found less time for her photography. With Maynard away on sketching and painting trips, she chose to spend her time with the children during their early years. The Depression, however, changed their lives drastically, nearly destroying the couple's earning capacity. Maynard and Dorothea made the difficult decision to live out of their studios and to farm out their children to friends and relatives. While this arrangement seemed appropriate at the time, it caused turmoil in the family and was a source of unhappiness to Lange's children even through their adulthood.

The crisis of the Depression also brought a dramatic change in Lange's photography. Fourteen million people were out of work, and the unemployed languished in the streets. They had no shelter, no prospect of jobs, and, at that time, no planned relief. The nation shifted direction, and many photographers moved quickly to capture its darkening mood.

Looking out of her studio window one day, Lange saw a breadline that a rich woman known as the "White

Angel" had set up. Running down into the street, she took a remarkable photograph. It would not only focus attention on a new phase in American life; it would also change her own.

LEAVING THE STUDIO

The dramatic difference between her studio pictures of the wealthy and privileged and the outdoor photographs of men at the depths of despair caused Lange to reassess her career. She left her studio as often as possible, mingling fearlessly with "tormented, depressed and angry men. I'd begun to get a much firmer grip on the things I really wanted to do in my work."[1]

Lange's photographs began to gain attention. Her poignant pictures of workers striking for better conditions on the San Francisco waterfront made a particular impression on the public. Lange had an exceptional ability to capture the nation's social conflicts and natural disasters through telling moments in the disrupted lives of ordinary people.

In 1934, Lange's work came to the attention of Paul Taylor, an economics professor at the University of California at Berkeley. Taylor, whose concern for the oppressed had led him to conduct studies of migrant laborers in the Southwest, asked Lange to photograph some self-help cooperatives set up for the unemployed. The photographs were exhibited at the University of California, sponsored jointly with the State Emergency Relief Administration. A second exhibit of the work led photography legend Ansel Adams to comment of Lange:

She is an extraordinary phenomenon in photography. She is both a humanitarian and an artist. To my mind, she presents the almost perfect balance

*between artist and human being. Her pictures are
both records of actuality and exquisitely sensitive
emotional documents.*[2]

In 1935, Dorothea Lange divorced Maynard Dixon
after years of estrangement. Her work with Taylor, how-
ever, was the beginning of a professional and then per-
sonal relationship between them.

Paul Taylor continued to conduct studies of poverty
and migration among agricultural laborers. He asked the
State Emergency Relief Administration to include Lange
in an exploration of rehabilitation needs for migrant
workers. Although the organization had a rule against
hiring photographers for the project, Lange was signed
on—as a clerk-stenographer. As long as she could go
into the field to take her photographs, Lange did not
care what her job title was.

The job extended Lange's range, proving that she
could get the shots she wanted without disturbing the
privacy of her subjects. Naturally skillful at dealing with
people, she took time to ask them about themselves and
carefully scribbled down their exact words to enhance
the power of the photographs. The difference between
the "silent people in the city" and the "talkers" in the
migrant camps intrigued Lange.

Impressed with her work, Roy Stryker of the Farm
Security Administration (FSA) invited Lange to become
staff photographer for the historical division of the FSA,
an arm of the U.S. Department of Agriculture whose
goal was to win public support for social projects.

Lange recorded the many faces of American agricul-
ture: the western migration of sharecroppers, tenant
farmers, and small-farm owners forced off their land by
drought and mechanization. Paul Taylor was appointed
adviser to the project, and the two continued their close

association. In fact, in 1935 they married and combined their families—Lange's two and Taylor's three children.

AWAKENING A NATION'S CONSCIENCE

Despite her increased domestic responsibilities, Lange intensified her work, pressing on with her investigation of workers and their lives. In March 1936, she took "Migrant Mother," the photograph that made her famous and came to epitomize the suffering of so many during the Depression. Several years before she died, Lange related the story of how the photo came about in a *Popular Photography* article, "The Assignment I'll Never Forget":

> *The pea crop at Nipomo [California] had frozen and there was no work for anybody. . . . I saw and approached the hungry and desperate mother, as if drawn by a magnet. I do not remember how I explained my presence or my camera to her, but I do remember that she asked me no questions. . . . I did not ask her name or her history. She told me her age, that she was 32.*
>
> *She said that they had been living on frozen vegetables from the surrounding fields, and birds that the children had killed. She had just sold the tires from her car to buy food. There she sat in that lean-to tent with her children huddled around her, and seemed to know that my pictures might help her, and so she helped me.*[3]

As soon as Lange developed the photographs, she ran to the *San Francisco News* editor, exclaiming that the pea pickers, devastated by a crop failure, were starving. The editor wrote an editorial and a story, which

Dorothea Lange in 1937

mentioned the "chance visit of a government photographer" to the migrant camp, and ran them alongside two of Lange's photographs. A day later the *News* carried a United Press report that the federal government was rushing 20,000 pounds (9,072 kg) of food to the 2,500 "ragged, ill and emaciated" men, women, and children.

Years later, when a retrospective of Lange's work was held at the Museum of Modern Art, curator George Elliott spoke of "Migrant Mother." "This picture, like a few others of a few other photographers," he explained, "leads a life of its own. That is, it is widely accepted as a work of art with its own message rather than its maker's; far more people know the picture than know who made it."[4]

VOICE OF THE DISFRANCHISED

Lange's work with migrant workers continued throughout the 1930s until the end of the Depression. Her photographs inspired many, including writer John Steinbeck, whose best-selling novel *The Grapes of Wrath* told the world in words what Lange's photographs had revealed in pictures. The book was made into a film, and during the movie's opening credits, a montage of Lange's photographs ran.

An American Exodus: A Record of Human Erosion, created by Taylor and Lange in 1938, was a nonfiction description of the Depression. Taylor wrote the text, Lange took the photographs, and the men and women studied told their own stories through direct quotations. The book's purpose was to shock the nation's conscience. It might have become a popular success, but the sudden outbreak of World War II turned attention away from migrant workers and toward Japanese Americans.

Soon after Japan's surprise bombing of Pearl Harbor, a military decision was made to clear the West Coast of

Japanese Americans, despite the fact that two thirds of them were native-born Americans with full citizenship rights. In a stringent and unusual forced migration, 110,000 men, women, and children were ordered to report for internment in hastily constructed camps in isolated inland areas.

The newly created War Relocation Authority hired Dorothea Lange to document the internment. With a heavy heart, she took pictures of Japanese Americans from the San Francisco Bay area trying to sell their businesses, packing their personal belongings, and reporting to the assembly centers. She also captured on film the angry anti-Japanese attitudes of some of the region's residents.

Lange also took many photographs in the Manzanar internment camp in northern California. Although other photographers documented the resettling process, Lange is known for her work's sensitivity and poignancy. Years after spending time with a former university student whose child had died due to harsh conditions in the internment camp, Lange reflected in an interview that his "life is dedicated to the memory of that child."[5]

Lange spent the rest of her life photographing people in nations throughout the world, including Ireland, India, Ecuador, Venezuela, and Egypt. One of her last projects dealt with the roles of women in different parts of society. "The American Country Woman" captured the daily demands of country life on women and was published in 1966, a year after Lange's death.

A NEW LOOK AT FASHION
Born the same year as Dorothea Lange, Louise Dahl-Wolfe made her name in a different artistic realm: as a photographer in the world of fashion. Yet her work has

as much to do with taking striking portraits of people in interesting backgrounds as with the way her subjects were dressed.

In the same way that Gertrude Käsebier served as role model for Imogen Cunningham in the early 1900s, Louise Dahl-Wolfe was inspired to enter the field by another older woman photographer. In her case it was Anne Brigman, whom Dahl-Wolfe met while an art student at the California School of Fine Arts, now the San Francisco Art Institute, which many women photographers attended over the years.

Like many women photographers before her, Louise Dahl-Wolfe abandoned plans to paint and turned to photography. Her intensive studies at art school made a major imprint on her photography work, a fact she readily acknowledged. "If you want to learn the principles of design and composition for photography, go to art school!" she wrote in her autobiography, *A Photographer's Scrapbook.*[6]

Dahl-Wolfe, however, recognized the difference between photography and painting. In *A Photographer's Scrapbook*, she wrote:

> *Photography, to my mind, is not a fine art. . . . [I]t has difficult limitations, and the photographer hasn't the freedom of the painter. One can work with taste and emotion and create a meaningful photograph, but the painter has the advantage of putting something in the picture that isn't there, or taking something out.*[7]

A trip to Italy and North Africa with friend and fellow photographer Consuelo Kanaga provided two important signposts in Dahl-Wolfe's early career: she bought two cameras and she met sculptor Mike Wolfe, whom she later married. Fascinated both by North

Africa's light and its people, she was to return often with her husband, for professional and personal inspiration.

Among her early efforts were photographs of still lifes and mountain people, reproduced in *Vanity Fair* to critical approval. Her career as a freelance photographer also included interiors for a San Francisco design firm and still life subjects for several magazines.

By the mid-1930s, Louise Dahl-Wolfe had accepted a staff position with *Harper's Bazaar* magazine. Before the introduction of the exposure meter, she had taught herself darkroom printing and negative developing to speed the exposure process. She felt most comfortable in her own studio, and the magazine departed from tradition to allow her to work there.

At first, Dahl-Wolfe photographed still lifes and clothing accessories, then portraits and fashion shots. The magazine gave her an enviable freedom that allowed her to do creative work. Coming to fashion photography at a time of formal, artificial European elegance, Dahl-Wolfe brought a fresh, distinctly American vision that was informal and intimate.

COLOR COMES INTO ITS OWN

Louise Dahl-Wolfe was one of the first fashion photographers to take models to distant locations, from Europe and Africa to Hawaii and South America. She was very exacting in her placement of the model and props. Her daring composition and preference for daylight, and her pioneering use of color set her apart from other fashion photographers.

Although color materials were often difficult to handle, Dahl-Wolfe learned to use them outdoors as well as indoors. She was also candid about her feeling that men, "with their pretty standard sense of color," were less creative in this area than women.

Over the years, working with several heavy cameras around her neck at a time, Dahl-Wolfe wore down vertebrae in her back and had to be put into traction. After that painful experience, she adopted the use of a tripod.

Throughout her career, Dahl-Wolfe had a warm relationship with her artist husband and appreciated his moral support. She often praised him for calming her down during difficult sittings in the studio: "When I became excited, Mike could soothe the situation, bringing order to it. . . . [W]ith his marvelous sense of humor, he could bring me down off my royal horse."[8] Mike Wolfe was helpful in many ways, assisting with business problems and performing domestic chores. He also was willing to stop his own artwork—drawing, making lithographs, sculpting, or painting—to create an unusual background setting for his wife.

PHOTOGRAPHY AS PROPAGANDA

During World War II, Louise Dahl-Wolfe joined other artists in a volunteer anti-Nazi propaganda effort. She created a dramatic and widely distributed photography series, "The Walls Have Ears," which depicted a half-hidden Adolf Hitler listening in on Americans in places as ordinary as the beauty parlor and the supermarket. The secretary of the navy praised the campaign to eliminate careless talk about war information.

Louise Dahl-Wolfe also took many photographs of public figures: actors, writers, artists, musicians, and politicians. Although she tried to cooperate with all of them, she stuck to her own personal values. Once, when Dahl-Wolfe was in Mexico photographing actress Delores Del Rio, she asked her subject to stand against a whitewashed wall. When Del Rio refused because it was her servants' quarters, Dahl-Wolfe was infuriated by the woman's attitude. She agreed to take the picture

elsewhere but made sure that her camera was empty of film.

Indeed, emotion for Dahl-Wolfe was one of the most critical ingredients of a picture. She once wrote:

> It is one of those intangible elements which the person who views the photograph senses rather than sees, which heightens enjoyment of a picture. Whenever I take a picture, I look at the first finished print and ask myself, "Have I captured the feeling of the scene?" [9]

Louise Dahl-Wolfe's words fit the approach of original photographers in any age. Certainly artists like Margaret Bourke-White, determined to work where the action was, had equal resolve to "capture the feeling" of dramatic and dangerous scenes.

Chapter Six

Exploring a Wider World: Bourke-White, Norman, and Morgan

Like Dorothea Lange, Margaret Bourke-White studied with the supportive and foresighted photographer Clarence White. Although both of these students of White's were dedicated to social realism, their approaches to documenting the world widely diverged.

In opening her lens to the broad range of human experience, Bourke-White also differed from two other contemporaries: Dorothy Norman and Barbara Morgan. Norman and Morgan, though wide-ranging in their interests, were primarily personal in the worlds they chose to capture on camera.

As a child and young woman, Margaret Bourke-White enjoyed photography as a hobby. After a failed early marriage to a graduate engineering student, she found her photographic talent useful as a way to finance her remaining college education at Cornell University, the sixth college she had attended. It was a skill that would bring the photographer acclaim for many firsts.

From her earliest days with a camera, Bourke-White was intrigued by America's industrial strength. After working as a freelancer, she became the first staff photographer for the business magazine *Fortune*. At the magazine, she concentrated on images of heavy machinery in factories. Her work showed attention to clean and crisp lines and a 1920s fascination with the new technology.

Bourke-White traveled widely for *Fortune*. She flew to Germany, studying industrial subjects and compiling a chilling essay on German rearmament published six years before the beginning of World War II. She also made several trips to the Soviet Union, where she took the first of many photographs contrasting the small scale of people to the immensity of massive machinery. In her autobiography, *Portrait of Myself*, Bourke-White describes her feelings about being the first professional photographer allowed across Soviet borders: "With my enthusiasm for the machine as an object of beauty, I felt the story of a nation trying to industrialize almost overnight was just cut out for me!"[1]

Shortly afterward, Bourke-White was sent to cover an American calamity: the great drought of 1934. She described the scene:

> *[I saw] . . . endless dun-colored acres, which should have been green with crops, carved into dry ripples by the aimless winds. I have never seen people caught helpless like this in total tragedy. They had no defense . . . no plan. They were numbed like their own dumb animals, and many of these animals were choking and dying in drifting soil.*[2]

The assignment proved the beginning of Bourke-White's awareness of people as sympathetic subjects

whom she could photograph in a broader context than she had ever considered. Feeling a great need to "understand my fellow Americans better," she realized she needed a writer to collaborate on the story.

WORDS AND PICTURES OF HARD TIMES
Bourke-White soon heard about Erskine Caldwell. According to Bourke-White, Caldwell was interested in meeting "someone with receptivity and an open mind, someone who would be as interested as he was in American people, everyday people."[3] Caldwell had chronicled the lives of poor, rural Americans in his best-selling novels *God's Little Acre* and *Tobacco Road*. His initial misgivings about working with a woman gave way to admiration for Bourke-White's skills, and the two quickly became a team in creating the photo-documentary essay. (They were even husband and wife for a time.)

Traveling through eight southern states, they spent intense periods of time interviewing and photographing tenant farmers in the grip of economic calamity. The people they studied were generally suspicious of strangers, but Caldwell and Bourke-White were able to gain their trust as the sharecroppers sensed their genuine interest.

A native of New York City, Bourke-White at times felt hopelessly out of place. During one photo session, a woman had many homemade things carefully arranged on a wooden-box bureau. When Bourke-White rearranged these possessions for the photo session, Caldwell rebuked her for her callousness. Horrified at her own thoughtlessness, she determined never again "to do violence."

Bourke-White's photographs and Caldwell's captions were put into the dynamic work *You Have Seen Their*

Faces. The book contained images of environmental, social, and personal decay. Bourke-White's biographer Sean Callahan noted, "Where earlier Bourke-White had assembled machine parts into impeccable compositions, in 1936 she organized the casual bits and pieces of human existence into pictures that speak volumes about poverty, ignorance, and justice."[4]

You Have Seen Their Faces was generally well received and successful, but Depression chroniclers Walker Evans and James Agee roundly criticized the work. Evans called it "a double outrage: propaganda for one thing, and profit-making out of both propaganda and the plight of the tenant farmer. It was morally shocking."[5] This concern among other writers and photographers that Caldwell and Bourke-White had put their own words into the tenants' mouths for dramatic effect spurred Dorothea Lange and Paul Taylor to use direct quotations in *An American Exodus*, their compilation published two years later.

A MAGAZINE OF PICTURES

In 1936, *Fortune* publisher Henry Luce decided to start a serious weekly picture publication that would bring to a mass audience the face of the political and social issues of the time; that was the beginning of *Life* magazine. It was a tribute to women photographers that Luce chose Margaret Bourke-White to be *Life's* first staff photographer.

Her first assignment was to photograph the huge concrete structure of Fort Peck Dam in Montana. The editors had originally planned to do a straightforward illustrated story on the dam's construction, but Bourke-White did something far more interesting. She recorded a new kind of American frontier of shantytowns near the dam, with taxi dancers working for five cents a dance

Margaret Bourke-White in 1943

and children growing up in boomtowns. When Bourke-White's pictures arrived, right before deadline, the editors were stunned by the force of the photographs. They immediately decided to use the dramatic photographs in a lead story called "Franklin Roosevelt's Wild West" and put one of the images on the magazine's first cover.

Soon after her photo essay on life at Fort Peck Dam, Margaret Bourke-White took her single most famous photograph. She took this picture while covering for *Life* the Ohio River flood of 1937, one of the greatest natural disasters in American history. In the photograph, flood refugees, waiting for food in a poor section of Louisville, Kentucky, are shown in front of a billboard of a comfortable, well-fed family with a caption that reads: "World's Highest Standard of Living: There's No Way Like the American Way." The ironic picture is often used, even today, to comment on inequality, poverty, and deprivation in the United States.

Bourke-White had an uncanny ability to be in the right place at the right time. In the spring of 1941, shortly before Germany's surprise invasion of the Soviet Union, she was sent to Moscow, and she was ready, cameras in hand, when German forces reached the city. Her dramatic shot of an air raid, with the jagged Moscow buildings silhouetted against the explosions of the bombs, remains one of World War II's lasting images. Bourke-White was the only Western photographer in Russia at the time.

THE HOLOCAUST SEEN WORLDWIDE
Margaret Bourke-White was also on the scene with General George Patton and the American Third Army during the liberation of the Buchenwald concentration camp in Germany. As she recorded some of the war's

most poignant images, photographing the naked, lifeless bodies and the emaciated survivors—the "living dead"—Bourke-White found herself clutching her camera for support. Said Bourke-White of the experience:

[I used the camera as] almost a relief. It interposed a slight barrier between myself and the horror in front of me. . . . In photographing the murder camps, I hardly knew what I had taken until I saw prints of my own photographs. It was as though I was seeing these horrors for the first time. I believe many correspondents worked in the same self-imposed stupor. One has to, or it is impossible to stand it.[6]

After World War II ended, Margaret Bourke-White continued to photograph major stories, putting news of world events into context for Americans. One assignment sent her to India, where she developed a friendship with Mohandas Gandhi, pioneer of a movement of nonviolent resistance that was later adopted by such leaders as Martin Luther King, Jr.

Bourke-White closely observed the scene as Gandhi's dream of peaceful unification of his country was destroyed by the partition of the country into Hindu India and Muslim Pakistan. She documented the bloody riots resulting from ancient religious hatreds. As she had in Germany, the photographer moved amid the dead and dying, calmly producing works she felt obliged to pass on to others. She again found herself at the site of a seminal world event: soon after a conversation with Gandhi, she watched a Hindu fanatic murder the leader of nonviolence.

Throughout her travels, Margaret Bourke-White followed the changes in the lives of women around the world. She documented women in India and Pakistan

leaving seclusion to become actively engaged in their new nations and women in the Soviet Union working as closely as men with machinery. She also produced studies of the brutal environment of South African gold miners and the human side of guerrilla warfare during the Korean War.

While covering the Korean War, Bourke-White had an experience that may have led to her contracting Parkinson's disease, an illness that disabled her years before her death in 1971. Bourke-White caught a chill when, after an overnight stay in an area in the midst of an encephalitis epidemic, she raced to the airport to get her story back to New York. In her memoirs, she wrote:

> Parkinson's Disease and encephalitis are very close. . . . Parkinson's may lie dormant for some time until some stress calls it forth. Whether my frantic efforts at the airport did anything to precipitate Parkinson's, I will never know. One thing I do know, if I had been in a position to make a choice between getting my photographs against the risks involved, I would still choose to get my story— Parkinson's or no Parkinson's.[7]

A PERSONAL PERSPECTIVE

Dorothy Norman, a contemporary of Bourke-White's who also traveled to India in the 1940s, provides a different insight into photography. A newspaper feature on a recent exhibition of her photographs at the Philadelphia Museum of Art describes her work as "severely personal. She didn't seek out subjects, but rather responded to people, places, and things she encountered in her daily life. And she confined herself to a few themes, all of which held personal meaning for her."[8]

Born in Philadelphia in 1905, Dorothy Norman moved to New York with her new husband, Edward, when she was twenty years old. Although she was wealthy, she was unwilling to join in the social lifestyle of the women of her time. Instead, she volunteered for the Civil Liberties Union, the Urban League, and the movement to spread information about birth control—all of which promoted what were considered radical ideas in the 1920s and 1930s.

Interested in modern art, Norman discovered the Intimate Gallery, run by its founder, Alfred Stieglitz. She began a friendship with the legendary photographer, who inspired her lifelong commitment to art and photography. She also became a fund-raiser, helping to finance a new location for another gallery, called An American Place. She assisted Stieglitz at this new gallery and soon became a part of the group of artists and writers who gathered there. For a young woman caught up in the cultural scene of the time, it was electrifying to associate with such artists as John Marin and Charles Demuth and such writers as Theodore Dreiser and William Carlos Williams.

Stieglitz gave Norman a new appreciation for the art of photography. Although he had never been a teacher, he discussed his own work, then lent her a camera and encouraged Norman to begin to take photographs. In the introduction to her recent exhibition's catalog, Norman described her early experiences with the Graflex camera, which opened up a new world to her. She tells of being increasingly challenged by split-second choices: what should she emphasize, and what should be sacrificed?

With Stieglitz's guidance, encouragement, and support, Norman gradually developed her own technique and style. Throughout her career she photographed people, particularly close-up. Subjects included her hus-

band and children, Stieglitz, and the great artists and writers who gathered at the gallery. "I love people and how they look," she once said. "I wanted to show just what was there."[9]

Nature, especially flowers, captivated Norman. She explained her fascination:

> I would peer into my camera, obsessed by the trembling edge and texture of white in a petal. . . . [T]he petal behind, beside, was blurred, thin, almost transparent. The one I concentrated on became sharp. I shut down my lens, held my breath. I clicked, again and again. Each moment, the light changed. Did I catch anything or not? I was never certain, but I was transformed.[10]

By the late 1920s, Dorothy Norman had developed a close association with Alfred Stieglitz whose wife, painter Georgia O'Keeffe, had left to paint in New Mexico. Norman became his first and only student, as well as his friend, inspiration, biographer, and lover. The forty-year-plus difference in their ages did not impair their relationship.

After Stieglitz's death in 1946, Dorothy Norman moved into a wider world. She had created a periodical, *Twice A Year: A Semi-Annual Journal of Literature, the Arts and Civil Liberties*, which she published from 1938 to 1948. Norman had created the periodical with the hope that modern artistic expression and significant discussion of political threats to civil liberties could influence and broaden public thinking.

She continued to write about civil liberties, discrimination, and Indian independence. After meeting Jawaharlal Nehru, Mohandas Gandhi's successor, in New York, Norman helped him to advance his cause in the United States. She introduced him to influential people,

and later published two volumes of his speeches. She also became friendly with his daughter, future Indian leader Indira Gandhi, and other members of his family, and photographed them on her trip to India in 1950.

Norman photographed other important figures in arts and politics as she continued to travel and capture the world she saw. In *Intimate Visions*, she shares her understanding of photography:

> *My photography grew and grew. It encompassed nature, people and architecture—subjects I felt passionately about and loved. In size, my prints always remained small, but I tried to make the images as large and bold and as beautiful as life itself.*[11]

Dorothy Norman was a writer and a photographer with a definite point of view, yet, as she said in a recent interview, she never considered becoming a photojournalist. She added that, while she didn't know if being a woman was an advantage, she never experienced any difficulties in photography because of her gender, and always had cooperation from her subjects.[12]

SEEKING HARMONY AND RHYTHM

While nature and architecture inspired Dorothy Norman to photograph, Barbara Morgan was caught up in the world of dance. Born in Kansas, she studied art and painted in California before turning to photography well after the start of her marriage to writer and photographer Willard Morgan.

As a student at the University of California at Los Angeles, where she later taught art, Morgan had developed an appreciation of the arts of China and Japan. The Asian arts and themes of flexibility and optimism were

reflected in her paintings. These influences, however, ultimately combined to produce the photographic works for which she is most noted.

Morgan strongly believed that her children came before her art. The birth of her second son in 1935, with its increased responsibilities, made painting in daylight hours difficult, if not impossible. Because Morgan had frequently assisted her photographer husband (and once helped then unknown American photographer Edward Weston mount a show at UCLA), her husband suggested that she try the art of photography. Realizing that a photograph could be a medium of artistic expression revealing the rhythm and harmony of life, Barbara Morgan turned her hand to this art.

Morgan worked at night when the children were asleep or Willard was home to take care of them. Using black-and-white film, she found artificial light as useful as daylight. She also explored photographic technology, testing equipment and materials. Her photographic experimentation paired well with her desire to capture the experience of dance.

Long fascinated by people who use rhythm for their art, Morgan felt a kinship to the Indian and Spanish southwestern influences of famed modern dancer and choreographer Martha Graham. She approached Graham about a photographic series on her dance company, and the dancer readily agreed.

Morgan did not photograph actual performances. She preferred first to study the choreography of the particular dances, then work with the performers to capture the most significant gestures. As they performed for her camera, the dancers also offered interpretation. The resulting book, which was completely designed by Morgan, including layout, headings, and type, was *Martha Graham: Sixteen Dances in Photographs.*

The work of Martha Graham is movingly shown in

one of the famous "Letter to the World" photographs, often referred to as "Kick." This is Graham's interpretation of the life of the poet Emily Dickinson after she gave up her tragic love affair. The "Letter to the World" series is significant not only for the photographs themselves, which dramatize total freedom of movement, but also for the work they influenced decades later. Morgan also photographed other leading dancers and choreographers, including José Limón and Merce Cunningham.

PHOTOMONTAGE AND SYNCHROFLASH

While working on the Graham book, Morgan began to work with photomontage. She found the impressions of New York City too complex to express in a single picture. She preferred to mix visual and verbal images of people, places, and mood. Photomontage showed her talent for design and her vivid imagination.

Barbara Morgan also gained attention for her unusual use of artificial lighting, particularly the synchroflash technique. Synchroflash and speedlamps allowed her to illuminate only what she chose, helping her dramatize the areas important for the photograph. In a book coedited by her husband, *Graphic-Graflex Photography*, Morgan wrote:

> By controlling direction and intensity I can launch light as a dynamic partner of dance action. . . . [L]ight is the shape and play of my thought . . . [it is] my reason for being a photographer.[13]

A teacher and mentor as well as a practitioner during a long life—she died at the age of ninety-two—Morgan had wide-ranging interests, from psychology to anthropology and sociology. These interests undoubtedly influenced her work of social commentary during the 1930s

and 1940s, including sensitive images of underprivileged children in New York City.

In the 1940s, Barbara Morgan photographed children at summer camp. Shaken by a radio announcement about the burning of the Warsaw Ghetto—as she listened to the laughter of American youngsters at play—she decided to capture their happy summer experience as a statement of hope for the future, after the devastating losses of World War II. The book, *Summer's Children: A Photographic Cycle of Life at Camp*, was published in 1951 by Morgan and Morgan. (Barbara Morgan served as unofficial consultant for her husband's publishing endeavors; the firm Morgan and Morgan is now run by their two sons.)

The dislocations of two world wars affected many women photographers: those who were caught up in it, and those who watched its effects on the United States and its people. Yet the artistic visions of photographers such as Dorothy Norman and Barbara Morgan were primarily personal, private glimpses of the world they chose to record.

The 1950s brought a relaxation from the cares of wartime and a yearning for "normal life." In magazines and newspapers, women photographers recorded the cheerful moments of life for a wide audience eager to return to happier times. But they also began to document changes in the nation's mood during a decade filled with intimations of the turbulent years to come.

Picturing Rebellion: Orkin, Arnold, Arbus, and Dater

While often differing from each other in style and subject, the photographers of the 1950s believed in photojournalism and its ability to offer an honest depiction of life around them. Ruth Orkin, who began her photojournalism career in college and later worked for such varied magazines as *Life*, *Cosmopolitan*, and *Ladies' Home Journal*, understood the importance of her work. "Documentary photography," she once said, "is what's real. And reality is what moves people in the long run."[1]

Ruth Orkin gained a reputation for her street scenes, most of which she shot out of her apartment window in New York. She took one of her strongest photographs in an old section of Greenwich Village, where the neighborhood was alive with people, with Polish and Irish immigrants, "even in the midst of dirt and decay," she later reflected.[2]

Another photograph for which Orkin is known is "American Girl in Italy," which pictures a young Ameri-

can woman avoiding the greetings of a group of Italian men. Viewed by modern eyes, the 1951 photograph can seem sexist and demeaning to women. But Orkin, while mindful of sex discrimination and harassment, preferred to emphasize cultural differences as the focus of the picture.

Eve Arnold, a contemporary of Ruth Orkin's, has also had a full career as a photojournalist. As a child, she received a camera as a gift from a friend, and she experimented with different techniques as a pastime into adulthood. During World War II, Arnold took a job in a photo-finishing plant when her graphic designer husband went into the armed forces. On his return, she gave up her job to have a child, but she still considered herself a photographer.

Arnold later took a course at New York's New School for Social Research, where her earliest assignment was a fashion show in Harlem. The prints were later published in several periodicals. Her consistently strong work led to an invitation to become the first woman to join the newly created photographers' cooperative, Magnum.

COVERING WOMEN'S STORIES

As was common for women photographers in the 1950s, Arnold was sent to do stories about other women and minority groups, subjects that magazine editors of the time considered less important. She soon developed a reputation for quality work that enabled her to suggest—and receive permission to do—more unusual, and sometimes more dangerous, stories.

Arnold has never been afraid to take on assignments that put her in personal danger. One such project, which dealt with the life and work of civil rights leader Malcolm X, involved considerable risk.

Eve Arnold in 1963

Throughout the ambitious project, which lasted a year and a half, Arnold was treated professionally by Malcolm X and the Black Muslims. The more militant African Nationalists, however, treated her with suspicion. After one photography session she discovered cigarette burns on her dress, near the pockets where she had kept her film. It was obvious that while Malcolm X wanted her to do the story, the African Nationalists did not. She persevered, however, and produced probably the definitive photographic essay on Malcolm X, which appeared in *Life* magazine.

Throughout her career, Eve Arnold has understood the importance of knowing how to move in and fit into the world she is photographing to take the pictures she

wants. According to Arnold, being a woman photographer has made fitting into different worlds easier:

> Men like to be photographed by women, and women don't feel that they have to carry on a flirtation, which they often do with a male photographer. . . . Most of the time, it's been a blessing to be a woman photographer.[3]

And being a woman was an absolute necessity for Arnold's "Behind the Veil," a series on why some Arab women continued to wear veils.

In 1980, the American Society of Magazine Photographers gave Eve Arnold a lifetime achievement award. It was the first time the organization had ever recognized a woman. The honor, however, was shared with Louise Dahl-Wolfe. Reflecting on the situation, Arnold drew on her knowledge of the Arab world:

> It seemed to me that this was the Arabic system where, by law, two witnesses who are women are the equivalent of one man. . . . As I got up to accept the award, all I could think of was "you're trying to catch up by giving it to two women instead of one." [4]

IMAGES OF THE CIVIL RIGHTS MOVEMENT

Louise Martin was another 1960s photographer. The civil rights movement was her early and continued focus. Determined from childhood to become a photographer, she earned a degree from Denver University's School of Photographic Arts and Sciences. Martin was the only black woman then enrolled. She later became the owner and operator of a portrait and commercial

studio in Houston and persevered through a number of setbacks.

Martin was the only black photographer, male or female, to become a member of the Southwestern Photographers' Convention in the early 1950s. Asked to join the convention and exhibit her photographs, she refused because the Texas hotel did not allow blacks to use the elevator. The organization's president arranged to hold the exhibition in the hotel mezzanine, where there was no need to use the elevator. Martin was the star of the exhibition and soon after joined most of Texas's professional photography and businesswomen's organizations.

Louise Martin's career coincided with the beginning of the civil rights movement in the mid-1950s. As an admirer of Martin Luther King, Jr., Martin had the opportunity to photograph him at the graduation ceremony of a local black college in Houston. In 1968, two black Houston newspapers chose her to cover King's funeral. Her photographs of King's family at the funeral provided some of the era's most poignant images.

Besides Louise Martin, there were many other women photographers who documented the civil rights movement during its height in the mid- to late 1960s, from King's "I Have a Dream" speech at the Lincoln Memorial to the many demonstrations and marches throughout the South. Elaine Tomlin was noted for her images of urban riots and rural poverty and went on to become the official photographer for the Southern Christian Leadership Conference. Photographer Miki Ferrill also covered civil rights marches and antipoverty demonstrations, in addition to street gang activity in Chicago during the 1960s.

PICTURE AS METAPHOR

The social turmoil of the 1960s inspired many photographers, including Diane Arbus, who was one of the first

to capture the new and difficult reality of American life. Photography historian Naomi Rosenblum notes that Arbus's images "appeared to many as metaphors for the uneasy dislocation of a society at war with itself and others."[5]

Diane Arbus actually began her career in a fashion area akin to that of Louise Dahl-Wolfe, but within a short time she had created her own sphere. By the end of her short but intense period of work, she had revolutionized portrait photography, producing work that defined the uneasiness of the 1960s.

Born Diane Nemerov, Arbus was raised in a talented family in New York City (her older brother Howard became poet laureate of the United States, and her younger sister, Renee, was a sculptor). At the age of eighteen she married Alan Arbus, an assistant to the advertising director at Russek's, her father's department store. Shortly after they were married, Alan gave Diane a camera. A simple gift, it was to open new worlds for the young woman.

After Alan returned from service in World War II, Diane's father hired the couple to create newspaper advertisements for Russek's. Although neither enjoyed fashion photography, they were financially and artistically successful. They also worked for *Vogue* and *Glamour*. In 1955, the Museum of Modern Art chose one of their images for its "The Family of Man" exhibition. "The Family of Man" was one of the first major exhibitions of photographs by black and white, and male and female artists.

Moving away from fashion work and later from her husband, Arbus began to explore her personal view of the world, a response to a growing self-awareness. Brought up in an atmosphere where people did not mention other people's peculiarities of appearance or personality, she was fascinated by flaws. She was drawn to the bizarre aspects of human existence.

In the beginning, Arbus photographed people who were obviously different—freaks and eccentrics. Her photographs of deformed or distinctive subjects have a uniquely disconcerting quality; they stare back with seemingly relaxed acceptance. One photography critic comments that "her subjects' gallantry lies in their willingness to face us, to offer themselves to be recognized."[6]

Arbus wanted her work to seek out the truths behind the trauma of these people's lives, and to question why ugliness and flaws should be socially unacceptable. Her intent was to raise questions about photography's purpose in a society. She was considered a personal journalist, committed to documenting the era's alienation, obscenity, and sexuality.

EXPLORING NORMALITY

Diane Arbus's work in the mid- to late 1960s turned to more ordinary subjects. Rosenblum describes Arbus's view of these subjects: "[Arbus found them] terrifying and alienated. . . . She sought to reveal psychological truths, reflecting her own deep distrust of conformity and the need to come to terms with her own turmoil."[7]

In photographs of the so-called "normal" people, Arbus shows that no one is really ordinary. Her smug socialites are overdressed and overfed, her patriots are ultraconservative and frightening, and her children seem often to inhabit a violent adult world. In these as in her earlier works, she looks with an unblinking eye at a society others would rather ignore.

Embracing reality, Diane Arbus felt the need to intensify the look of snapshots and news photographs, two strong influences on her work. She used direct flash, no matter how stark its shadows. She seemed to care little about careful composition and had an intense dis-

like of photographers whom she considered too aware of themselves in setting up their pictures.

Because Arbus sought out people not merely for their physical distinctiveness but for their uniqueness, she was not exploitive. She had great ability to empathize with her subjects and often developed a trust, and sometimes a kind of friendship, with them.

She was always eager to find a subject who seemed ordinary but had a certain odd, almost sinister quality. At a New York parade in 1967, Arbus found a teenage boy interesting, asked him to pose for her, and shot "Boy with a Straw Hat Waiting to March in a Pro-War Parade."

Three years later, the young man was driving a cab down New York City's Fifth Avenue, and Arbus hailed him. He recognized the photographer and asked her about the image. Arbus told him it was her most successful photograph, took down his address, and sent him the print.

..

HEAD-ON ENCOUNTERS

By the late 1960s Arbus had achieved the look for which she is best known: a direct encounter between photographer and subject that implies the subject's full collaboration. Some of this work was part of a three-person 1967 exhibition, "New Documents" at the Museum of Modern Art, which established a new direction in the social-documentary area of photography.

In 1970, Diane Arbus created some of her most powerful images, the "Untitled" series, taken at a home for retarded people. She continued to teach, as she had since 1965, first at the Parsons School of Design, then at Cooper Union and the Rhode Island School of Design. These teaching positions helped Arbus support herself at a time when, despite growing artistic success, her financial situation was shaky.

Diane Arbus in 1970

Diane Arbus took her own life on July 26, 1971, at the age of forty-eight. There are many who believe that she killed herself because of the difficulty of photographing the strange world in which she had chosen to work. But according to colleague Marvin Israel, that judgment is false. "Diane was delighted by the people she met," he said. "And perhaps the one thing that gave her total enthusiasm and energy was the possibility of finding more of these people. . . . She really never found despair from other people."[8]

Arbus has been given posthumous shows, including one in 1972 at the Museum of Modern Art, which became the most widely attended show of a single photographer's work in the museum's history at that time. That same year, she became the first photographer to

have her work exhibited at the Venice Biennale, a major international exhibition. Her photographs are still featured in museum and gallery exhibitions throughout the world.

Arbus once commented that there were things that nobody would see unless she photographed them. "For me," she explained, "the subject of the picture is always more important than the picture [itself], and more complicated. . . . I really think what it is, is what it's about. I mean it has to be of something, and what it's of is always more remarkable than what it is."[9]

FEMINISM ON THE MOVE

Judy Dater, born in 1941, is a photographer who exemplifies feminist awareness, a cultural movement that gained momentum in the late 1960s. Although her early work was of landscapes and interiors, she is known for her intense and truthful portraits, primarily of women. These portraits examine female identity through costume and role-playing. They also project the emergence of northern California as a distinctly new cultural force in what was about to become the "love generation."

A California native, Dater studied art at the University of California at Los Angeles and San Francisco State College, where she also earned a master's degree in photography. It was during her student days that she met Imogen Cunningham, who became her mentor and friend for the last decade of Cunningham's life. In her book *Imogen Cunningham: A Portrait*, Judy Dater describes her enjoyment in knowing this "photographer's photographer," so respected by her peers but relatively unknown until the 1970s.

Dater greatly admired Cunningham and was "constantly astounded that this delicate, pixieish woman could be so alive and alert. Her energy and enthusiasm

Judy Dater in 1994

were contagious, and I always felt better for having spent time with her."[10] Cunningham also influenced Dater's work, from Cunningham's large-format cameras and her "straight" approach to photography to the nude studies that scandalized Seattle in the 1930s.

Like Cunningham, Diane Arbus, and others, Dater is concerned with the human values of her subjects. Many of her portraits in the late 1960s and early 1970s were of nude and partly clothed figures. While the naked body is often less revealing than the face, her nude studies captured the new sexual freedoms associated with the growing feminist movement.

Dater came to such studies after photographing a wide variety of subjects, from landscapes to buildings. She also took many photographs of her friends before she recognized the objectivity she would gain from photographing strangers. Dater's subjects accept their sexuality and confront the camera with intensity. Each woman is an individual and offers a revealing sense of herself. The subjects exude a sense of urban sophistication, a marked contrast to the country women of Dorothea Lange.

REVEALING THE SELF

In her work, *The Woman's Eye*, Anne Tucker speaks of Dater's intention "not to document, nor to glamorize. For her the most important thing is that people reveal themselves to the camera and express something about themselves which definitely exists, though it may be hidden—perhaps even from themselves."[11]

In the mid-1970s Judy Dater produced a project on the urban woman, *Women and Other Visions*, with photography teacher Jack Welpott, to whom she was married from 1970 to 1977. Using natural light and a classical, straightforward approach, these psychologically revealing black-and-white portraits of women of widely diverse lifestyles capture the strength and mystery of each sitter.

Interestingly, the two photographers had different approaches to the work. In one photo shoot, Dater took a portrait of a woman named Joyce Goldstein in her kitchen, with utensils hanging over her head, which recalled Goldstein's profession as director of a cooking school. While Dater emphasizes the subject's individual strength of character, she also manages, subtly, to raise questions about the roles contemporary women chose to adopt. Welpott, on the other hand, photographed

Goldstein in her living room, which was decorated with Mexican artifacts. His portrait deemphasizes Goldstein's personality and makes her only one of the subjects in the picture. Welpott's work shows a greater awareness of the subjects' bodies and their fantasies than Dater's work, in which the women seem more forthright and better able to express their feelings and concerns as women.

Dater and Welpott's joint projects show a mutual exchange of inspiration; each had a strong influence on the other. Dater's interest in people compelled Welpott to reexamine his own approach to portrait work, while Welpott introduced her to a group of artist friends, including Cunningham. Meeting such artists gave Dater a lasting appreciation of what it means to be a photographer: energetic devotion to achieving excellence in the art.

Judy Dater's portraits addressed issues of universal concern during the 1960s and 1970s. She first gained popularity in the mid-sixties, when she and many other artists were addressing shifting cultural values.

A movement was growing toward direct confrontation in interpersonal relationships, social struggles, personal freedom, and such political issues as the Vietnam War. It would fall to the photographers who followed to capture this continuing turmoil as information and as art.

Chapter Eight

Loosening Barriers: Mark, Moutoussamy-Ashe, and Contemporaries

Throughout the 1960s and 1970s, the United States was rocked by social unrest over the Vietnam War and civil rights. The photographers who documented these times brought political, social, and cultural diversity issues to public attention.

The Vietnam War caused violent upheavals, particularly among young Americans who disagreed with their government's participation in the war. They held demonstrations on college campuses and city streets throughout the country, venting their anger over a situation they considered intolerable.

Mary Ellen Mark, who was just beginning her photographic career, was on the streets of Chicago with her camera during the Republican convention of 1968. She captured in her early photographs the human emotion she saw among antiwar protesters; her open and direct approach to the powerless and disfranchised is still at the core of her work decades later.

Mary Ellen Mark in 1996

A native of a Philadelphia suburb, Mark received degrees in fine arts and communication from the University of Pennsylvania in the early 1960s. Her interest in photography began during her graduate studies and deepened during an extended visit to Turkey. It was in Turkey that Mark took a now famous photograph of a

young Turkish girl who had assumed the body language of the women around her.

When she returned to the United States in 1966, Mary Ellen Mark set about becoming a professional photographer. Mark realized that the most effective way to get an assignment was to approach editors with pictures of a compelling subject. If they liked her idea and the photographs, they would buy the rights and assign a writer to the project.

During the late 1960s, Mark also worked as a still photographer for several movie productions. She earned a good salary taking movie star portraits, and the *New York Times* and *London Sunday Times* magazines published some of the production stills.

A turning point in Mark's career came in 1969 when she was photographing film director Federico Fellini in Rome for *Look* magazine. After hearing about a new English law allowing clinics to dispense heroin to registered addicts, she flew to London with a writer to work on the article "What the English Are Doing with Heroin." This dramatic close-up of drug users set the pattern for her documentary work on people on society's fringes.

Mark's work with film stills also led to a highly regarded project on women in a maximum security unit of a mental institution in Oregon. After photographing the actors for the film *One Flew Over the Cuckoo's Nest* in the hospital, she received permission to live with a writer in the security ward. They spent thirty-six days interviewing and photographing the patients for a book that became *Ward 81*.

Mark's experiences with the women of Ward 81 reinforced her long-held desire to concentrate her photography on people and their environments. And she realized that staying in one place for a long time brought her closer to her subjects.

Mark's involvement in the lives of her subjects during her many trips to India, with which she has devel-

oped a lifelong fascination, is evident in her work. She has taken photographs of people as diverse as prostitutes in Bombay, blind children in Calcutta, and circus performers and snake charmers in New Delhi. Because she has become familiar with the country, she is comfortable photographing subjects who might seem strange or offbeat to others.

Mark's familiarity was hard won. During her first several trips to Falkland Road, the Bombay area inhabited by prostitutes and transvestites, she was verbally abused and pelted with garbage. She persevered in her concern for the people of the area and slowly became accepted as a photographer and as a friend who would do them no harm.

Some of Mary Ellen Mark's work in India on a decidedly different theme was her piece about Mother Teresa, "Teresa of the Slums: A Saintly Nun Embraces India's Poor," published in *Life*. Mark did most of her photographing at the Home for the Dying in Calcutta, where she slowly gained access to the nun as she carried out her work. Mark was able to document the love of the hospice nuns for patients with the grimmest diseases, including leprosy.

Many other settings have provided Mark with opportunities for emotionally powerful photographs: a relief camp in Ethiopia, a homeless family living in their car in California, teenage runaways living on the streets of Seattle. In her own words, Mark photographs "people who are the victims of society, because I care about them. And I want the people who see my pictures to also care."[1]

A MATTER OF RESPECT AND BOUNDARIES
In an article in which she includes Mark in a list of "Photography's Top 100," Carol Squiers describes the photographer:

[She portrays] her subjects with gravity and respect usually accorded celebrity or power. She has a brilliant eye and profound empathy, which distinguish every photograph of the unempowered.[2]

Mark speaks of her early decision to photograph the unfamous and sometimes less fortunate people, a result of her desire to be a voice for them. Even though they are less advantaged, she believes them more worthy, more deserving to be photographed. The unfamous also make for better subjects: "They are innocent of the camera," she says.[3]

Mark also considers being a female a decided advantage in photography, particularly photojournalism, because access to the subjects is easier. She has noted that she has had very little difficulty getting into people's homes, for instance. Quite simply, people are less threatened by a woman; there is more trust. Even so, Mark says:

I go into every story thinking I'm going to fail. . . . Each story is like the first I've ever done. [Even in a difficult situation,] somehow I just fight it through and it happens. It's just a question of finding my access, then making strong photographs.[4]

As a sensitive photographer, Mark is concerned about being exploitative and stepping over boundaries of conscience and appropriateness with her photography. But after so many years in photojournalism, she believes that she has developed a sense for when something is going to happen and an instinct for how far to go.

Discussing the relationships she has developed with many of her subjects over the years, she has said, "Getting close to them brings me stronger images. . . . [T]hey

91

become used to my stepping into their lives."[5] Perhaps Mark's ability to become a part of the lives of these people stems from her obvious respect for them. For instance, a friendship with an Indian family, whom Mark photographed often, set the stage for a remarkable image when their little blind child first touched her adopted mother's hand.

AN INTERNATIONAL REPUTATION

Mary Ellen Mark has earned an international reputation for her work, which has appeared in magazines as diverse as *Life*, *Rolling Stone*, and *National Geographic*. For a magazine assignment, the photographer often shoots as many as two hundred rolls of film, then edits her selection to as few as forty photographs, from which the magazine chooses eight to ten.

Mark likes to shoot in color to heighten reality, but also uses black-and-white film when it suits the assignment. Although she claims she is not a technical photographer, Mark is proficient and believes that some technique, including knowledge of lighting, is crucial.

Mark lives and works in New York with her husband, film director Martin Bell. In the early 1980s, the two worked together on Bell's documentary film *Streetwise*, which grew out of Mark's *Life* assignment "Streets of the Lost: Runaway Kids Eke Out a Mean Life in Seattle." The film was nominated for an Academy Award in 1984.

Mary Ellen Mark has praised Bell's talent and independence—and his support of her work. "I could never have had the kind of traveling career I have without his encouragement," she notes.[6]

In 1990, Mark created a retrospective exhibition of twenty-five years of work at New York's International Center of Photography, with the companion book *Mary*

Ellen Mark: 25 Years. At the same time, she documented Indian circus performers, whose purity and innocence overwhelmed her. *Esquire* magazine wrote that "even after a quarter century, Mary Ellen Mark has not lost hers."[7]

ARTISTIC BOUNDARIES BLURRED

Mary Ellen Mark benefited from the recent loosening of barriers between fine and applied art. Another contemporary woman who has succeeded in fine and commercial art is Jeanne Moutoussamy-Ashe. A former news and documentary photographer, Moutoussamy-Ashe has created numerous photographic essays and the definitive history of black women photographers.

Jeanne Moutoussamy-Ashe is a Chicago native whose architect father encouraged her to study art and later supported her decision to become a photographer. A friend introduced Moutoussamy-Ashe to the camera at Cooper Union, and she was immediately drawn to a career in art through photography.

After graduating from college, Moutoussamy-Ashe joined the NBC News Center 4 as a photographer and graphic designer. While she experienced some mistreatment from other photographers on the job, she commented that "I doubt [it] came from my gender, but more from the competition of getting a good photographic position."[8] Despite her gender, she also was able to gain admittance into the locker room of the 76ers, Philadelphia's basketball team, with a pool of reporters.

During one of her assignments for NBC News, a benefit for the United Negro College Fund, she met and later married tennis legend Arthur Ashe. Their daughter Camera, named for her mother's work, was born in 1986. Throughout their marriage, Arthur Ashe encouraged his wife's work. In fact, it was he who influenced

Jeanne Moutoussamy-Ashe in 1993

her to put her ideas into book form. All three of her books, particularly the third, *Daddy and Me*, evolved from personal concerns.

The first book began as part of Moutoussamy-Ashe's college independent study on the west coast of Africa. A few years later, she spent time photographing a small community of African-Americans on Daufuskie, a South Carolina sea island. The photographs, which went on tour as a solo exhibition, were then compiled into her first book, *Daufuskie Island: A Photographic Essay*. Moutoussamy-Ashe explained that the work came out of "the curiosity of the link between the west coast of Africa and the East Coast of the United States."[9]

Moutoussamy-Ashe's second book, *Viewfinders: Black Women Photographers*, is the first published volume of biographies of African-American women pho-

tographers. Moutoussamy-Ashe began researching black photographers and realized there was little mention of women. The book grew out of that realization. She felt the importance of bringing these photographers to public attention. "Being a black woman," she notes in the book's introduction, "I was concerned. . . . I knew that the women had existed, that I myself was not a true pioneer."[10]

Once she found a publisher, she devoted her efforts to completing the research and conducting interviews with the women as quickly as possible, before any more photographers or their works were lost. Moutoussamy-Ashe focused the book primarily on the pioneering photographers, particularly those who documented their community or personal lives. She speaks admiringly of their "ambition and drive to produce work, often while confronting adversity."[11]

FROM JOY TO GRIEF

Arthur Ashe and Jeanne Moutoussamy-Ashe themselves confronted adversity shortly after the birth of their daughter: the discovery in 1988 that Arthur had contracted AIDS from a blood transfusion after heart surgery. A newspaper article forced them to make the announcement public less than a year before his death on February 6, 1993.

During Arthur's illness, the Ashes had been unable to find a book to explain AIDS to their young daughter. They decided to produce a photo book, *Daddy and Me*, written in Camera's voice and illustrated with Moutoussamy-Ashe's photos of father and daughter. The goal was to show children that people can live with illness and help others who are sick without being overcome by fear.

Daddy and Me is an extraordinary look at the impor-

tance of a child in the care-giving process. In her book, Camera speaks of her father's good days and bad days. She speaks of playing and reading with him, helping him keep track of his many pills, and going to the hospital with him. Soon after publication, Camera and her mother talked to Camera's first-grade class about the book and read parts of it to the youngsters, who had helped her through the difficult year.

After her husband's death, Jeanne Moutoussamy-Ashe oversaw the publishing of his memoir, *Days of Grace*, along with *Daddy and Me*. She also served as chairwoman of the Arthur Ashe Foundation for the Defeat of AIDS, an organization she dissolved in 1995 because she felt it had accomplished its fund-raising and information-giving goals.

The photographer also returned to her studio work. A longtime freelance photographer for magazines and others, Jeanne Moutoussamy-Ashe looks forward to the continuing growth of her photographic career, particularly in the area of portraits.

But it is the well-being of her daughter, Camera, that is at the center of her life. Jeanne Moutoussamy-Ashe makes it very clear that she intends to continue to "work at home. It is a part of my family life."[12]

THE SEARCH FOR CULTURAL HERITAGE

Pride in her heritage is a focal point of Jeanne Moutoussamy-Ashe's professional life. Ethnic self-respect is also evident in the work of other contemporary women photographers, including Native American Hulleah Tsinhnahjinnie and Hispanic-American Maria Martinez-Canas. The photography of these two women reflects their cultural background and ethnic identity.

A native of Phoenix, Arizona, Hulleah Tsinhnahjinnie attended the Institute of American Indian Art in

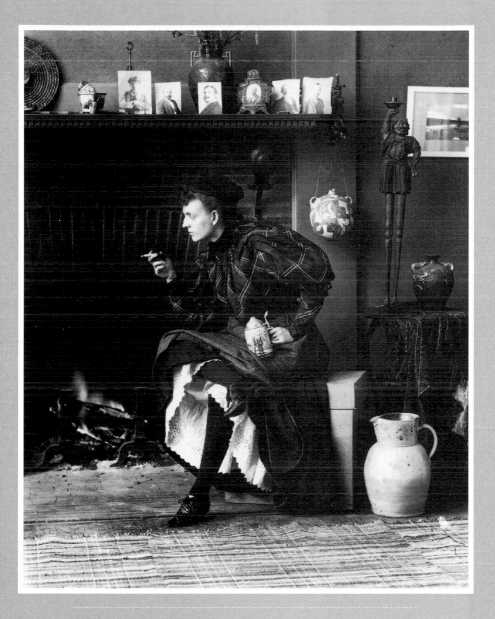

Frances Benjamin Johnston, "Self-Portrait," circa 1896

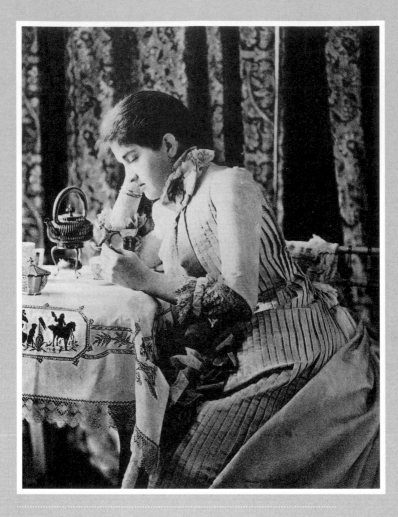

Catharine Barnes Ward, "Five O'Clock Tea," 1888

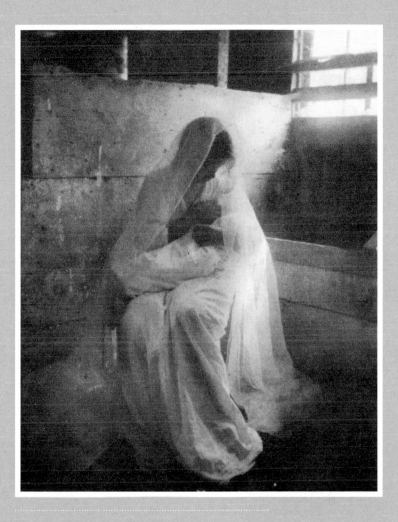

Gertrude Käsebier, "The Manger," 1899

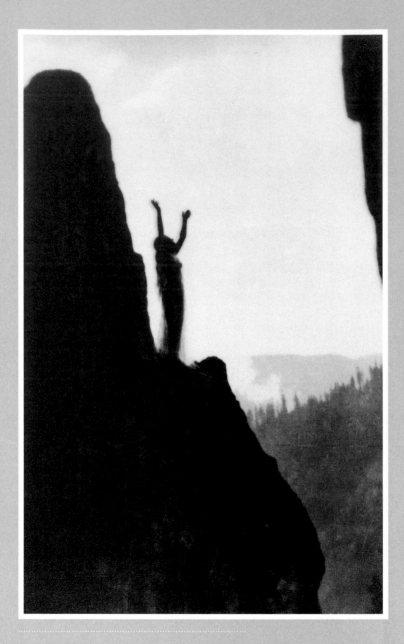

Anne Brigman, "Incantation," 1905

Anne Brigman, "Spirit of Photography," 1908

Doris Ulmann, "Portrait Study, Lang Syne Plantation," 1929

Laura Gilpin,
"Sunrise, San Luis
Valley," 1921

Imogen
Cunningham,
"False
Hellebore,"
1926

Imogen Cunningham, "Self-Portrait on Geary Street," 1955

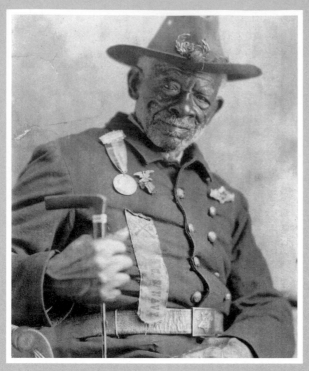

Elise Forrest Harleston,
"Grand Army of the
Republic Veteran,"
circa 1924

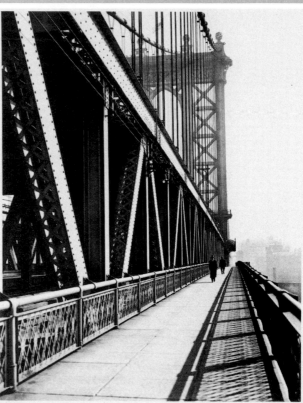

Berenice Abbott,
"Manhattan
Bridge Walkway,
New York," 1934

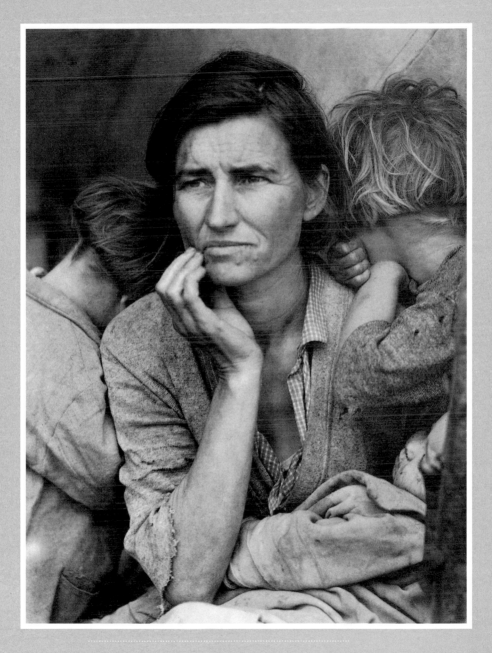

Dorothea Lange, "Migrant Mother," 1936

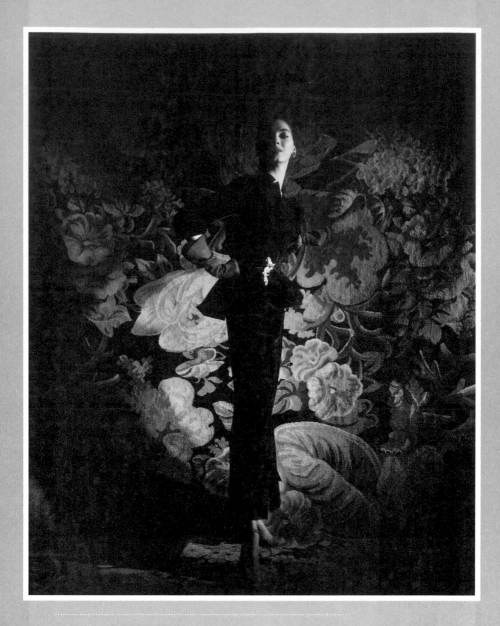

Louise Dahl-Wolfe, "The Couvert Look," 1949

Margaret Bourke-White, "Bombing of Moscow," 1944

Dorothy Norman, "Alfred Stieglitz," 1933

Eve Arnold, "Elijah Muhammad's daughter at a Nation of Islam Meeting," 1961

Diane Arbus, "Boy with a Straw Hat Waiting to March in a Pro-War Parade," 1967

Judy Dater, "Joyce Goldstein in Her Kitchen," 1969

Jeanne Moutoussamy-
Ashe, "Josette's
Wedding," 1981

Mary Ellen Mark,
"Ethiopia," 1985

Annie Leibovitz, "Self-Portrait," 1991

Cindy Sherman, "Untitled #193," 1989

Santa Fe, New Mexico, and the College of Arts and Crafts in Oakland, California. She became part of the Native American community in California, and it is this community to whom she directs her artistic efforts.

In an interview, Tsinhnahjinnie notes her interest in expanding the message of "native" art beyond its communities. The San Francisco art market was tempting: "If you worked in certain styles and motifs, you could become rich pretty quick. [But] that wasn't what I wanted to do!"[13] Instead she mounted a major exhibit, "Nobody's Pet Indian," at the San Francisco Art Institute. Set outside the Native American community, the exhibit consists of a series of photographic "installations." It uses humorous slogans to question onlookers about their recognition of real Native American artists beyond the stereotypes.

One of Hulleah Tsinhnahjinnie's key political efforts was her unsuccessful fight against a federal law that seeks identification of Native Americans as ethnically pure. The law requires artists to document their American Indian ancestry before they may display for sale any work they claim to be an Indian product. "This is cultural imperialism," she says, "a very subjective view of Native American sovereignty."[14] The photographer also believes that the law reflects a paternalistic standard on the part of the U.S. government toward Native American peoples.

Tsinhnahjinnie considers herself both an artist and an activist. For her, the roles are intertwined. Some of her exhibits, including "Nobody's Pet Indian" and "When Did Dreams of White Buffalo Turn to Dreams of White Women?," are primarily political. Another exhibit, "Heroes," is more personal. The photographs in "Heroes" are meant to be Native American "honor songs," or tributes to those who have had a part in creating the artist. Tsinhnahjinnie says, "As an artist in soci-

ety, you are like a messenger blamed for the message. The reward is when your community comes to you and says you've done well."[15]

..

SPANISH CULTURE FROM MANY LANDS
Another photographer who uses the American Southwest for inspiration is Maria Martinez-Canas. A native of Cuba who grew up in the United States and Puerto Rico, Martinez-Canas creates photographs that contain fragments of architecture, nudes, and landscapes, densely packed with imagery and forms. She creates unusual textural forms on each print by cutting shapes out of amberlith—a photographic material that blocks the light. These forms add an element of drawing to her manipulated photographs.

For Martinez-Canas, photography becomes a means of creating new signposts and landmarks, helping her to come to terms with her personal and cultural background. She considers herself an exile in the United States and travels often to nations of Spanish culture to get her artistic bearings.

Specific places have lost their recognizable identity in her work and have become elements of her multilayered, formal compositions. Martinez-Canas builds up her work by clustering and engraving many photographic images. They are created bit by bit from negatives, often flipped and turned sideways to make disorienting mirror shots.

Many women photographers today are searching for cultural identity—their own or that of groups important to their work. As they make their statements, these women extend the boundaries of the world as they know it—politically, artistically, or both. The result is photography as exciting as it is sometimes unsettling.

Images Without Boundaries: Simpson, Leibovitz, Sherman, and Burson

As women from varied backgrounds bring their perspectives to the world of contemporary photography, they experience differences among themselves as well as new challenges brought about by technological advances. They find they must stretch not only their imaginations but also their technical skills during this artistic revolution.

Photographer Lorna Simpson has pushed both political and artistic limits since her early work in 1982. This young multimedia artist was the first African-American woman to represent the United States at the international exhibition Venice Biennale and to have a solo exhibition in the "Projects" series of the Museum of Modern Art.

Noted for her confrontational images often set on large separate panels known as installations, Simpson mixes photography with short blocks of text and recorded conversations. Her intent is to expose the way

black women are treated in everyday language and imagery. Her photography is rooted in the storytelling tradition of African-American art, which uses literal and visual narrative to create art, partly personal and partly fictional. Lorna Simpson's work is known for its unusual approach to challenging issues.

A native of Brooklyn and Queens, Simpson had a traditional training in photography at the School of Visual Arts. Nontraditional approaches soon emerged, and continued during her graduate work at the University of California in San Diego. Her work expanded from simple black-and-white images to screens, larger-scale images, and text.

Simpson's first widely recognized project was a grouping of six large black-and-white photos entitled "Gestures/Reenactments." Of the effort, she says:

> *This work attempts to describe particular gestures and events that occur in a black environment (and more specifically, presents a small slice of the experiences of black American men.)*[1]

The six different gestures are coupled with seven segments of text. These words deal with domestic arguments between man and woman, job hunting, a shooting incident, and heroism. The artist challenges the viewer to discover the significance of the gestures based on clues in the text.

SYMBOLS OF DISCRIMINATION

According to art historian Deborah Willis, Simpson is "like other young African-American women artists working today, creating images that are highly symbolic and symptomatic. . . . [H]er work synthesizes conscious and

unconscious acts of aggression, discrimination, and alienation."[2]

In her clarion call for a reexamination of the lives of black women, Simpson makes a powerful presentation in her photographic approach. Her concern for identity takes the form of the voices and experiences of anonymous black women. She invites viewers to see the world as a black woman experiences it, an unsettling blend of gender and racial invisibility.

Lorna Simpson's deceptively simple combination of text and words produces a unique inquiry into matters of race, gender, and the body. She blends blankly generic photographs of African-Americans with short, provocative, and mechanically printed words to project challenging issues. Using language, gestures, and props—without facial expressions or other signs of individuality—the artist vividly projects artistic and political concepts. Contemporary audiotapes and relics of the past are often combined for dramatic effect. One photography critic has described Simpson as an artist who wants to change the world:

When relations between races, cultures, and genders are often confused and uncomfortable, Simpson's efforts to reveal the knots of ignorance and misunderstanding that restrict our sense of community have an importance that goes beyond the usual perimeters of art.[3]

BRINGING CELEBRITIES HOME

Annie Leibovitz is another photographer who pushes artistic boundaries. She has experimented with various approaches, but in her best-known work she captures

the images of famous people all over the world. In photographing celebrities, she is expressing popular culture through images, in marked contrast to Mary Ellen Mark and Lorna Simpson, who prefer to explore the spirit of the unfamous.

Leibovitz first took up the camera as a student at the San Francisco Art Institute. She was soon working professionally, however. Her first professional assignment came after a *Rolling Stone* editor saw Leibovitz's journalistic photographs of San Francisco's late-1960s counterculture and immediately put her to work for the new large-format magazine.

At first Leibovitz worried about taking the job. She later said:

> *The photographers I admired were not photographers who worked for magazines on assignment, but people who chose what they did from the inside—or so I thought at the time. And I wondered if I was betraying something. And then I found out what it meant to be published . . . especially on the cover of a magazine.*[4]

Annie Leibovitz's *Rolling Stone* covers chronicle the history of popular music over almost thirty years. Her first out-of-town assignment was photographing John Lennon of the Beatles in New York City in 1970. During the photo shoot, using a long lens, she came in close on his face. Suddenly, he looked directly at her and she snapped the picture. It was a startling experience for the fledgling artist. Said Leibovitz:

> *Here was someone whose music affected us for years, someone who loomed very large in my imagination—and he acted completely normal with me. He hung around, asking me what I*

wanted him to do. And I just got on with what I was there for—the work. John's way of relating set the precedent for how I wanted to work with famous people, successful people, celebrities, or whatever.[5]

CHALLENGING OBJECTIVITY

The Lennon assignment also changed Leibovitz's mind about photographic objectivity. She had originally believed in Margaret Bourke-White and the journalistic approach, whose object was to report what was happening as accurately as possible. Her view, however, changed. "I realized that you can't help but be touched by what goes on in front of you," she said. "Everyone has a point of view. When you trust your point of view, that's when you start taking pictures."[6]

In 1980, Leibovitz was again assigned to photograph John Lennon, this time with his wife, Yoko Ono. There was much discussion about what the famous couple would wear. When the shot was made, it was of a nude Lennon curled up against a fully clothed Ono. Leibovitz felt it had been both an important and graphically successful photograph. The picture was meaningful for another reason, for the artist and the mass audience, for within hours after it was taken, John Lennon was murdered outside his home.

By that time, *Rolling Stone* had become a four-color magazine, which presented difficulties for a photographer schooled in black-and-white, with its accompanying tones and highlights. In 1983, Leibovitz had to adapt her technique again when she moved to *Vanity Fair*, an even more celebrity-oriented publication with a broader range of subjects—writers, dancers, artists, and musicians of all kinds.

Leibovitz's work with celebrities is sometimes described as similar to an MTV sketch—elaborately staged, attention-getting, and fun. She has endless ideas for poses, but often it is her subjects, with a sense of their own images, who create the scenes.

Since the early 1980s, Annie Leibovitz has enhanced her reputation for dramatic, even shocking photographs. They include images of Whoopi Goldberg in a tub of milk, Roseanne and Tom Arnold mud wrestling, and a very pregnant, nude Demi Moore staring out from the cover of *Vanity Fair*.

PHOTOJOURNALISTIC IMAGES

Photography critics have differing opinions of Annie Leibovitz's celebrity photographs. Many of her documentary efforts, however, have been well received. In 1992, she went to Sarajevo in the former Yugoslavia to take a series of prints. The images, totally without glamour, project the ugliness of life in a war zone. A particularly sad photograph shows a bicycle lying in the road, with a trail of blood beside it. Its young rider, hit by a mortar round, died in Annie Leibovitz's car on the way to the hospital.

The Sarajevo photographs reflect Leibovitz's interest in journalism and photographer Henri Cartier-Bresson. Cartier-Bresson's work, particularly his street photographs, went beyond simple reporting to create a lyrical reality and seems to have influenced some of Leibovitz's most compelling documentary efforts.

Among the images that departed from her usual celebrity work were her moving images of Christmas Day at Soledad Prison in California. She captured the raw emotions of prisoners' relatives as they embrace their loved ones. The camera is focused directly on the weeping families, but they seem not to notice the intrusion. Even celebrities have not escaped Leibovitz's pho-

tojournalistic lens. She once shot the Rolling Stones on the road during an exhausting concert tour—unkempt, completely natural, and unconcerned.

Annie Leibovitz's popularity is astonishing. She is only the second living photographer to hold an exhibit at the National Portrait Gallery in Washington, D.C. During just five months, her 1991 exhibit attracted more than a quarter of a million people—the average number of Gallery visitors for a year. Soon afterward, her exhibit at the International Center for Photography in New York attracted seventy thousand visitors, which surpassed the record that her idol, Henri Cartier-Bresson, had set.

Robert Sobieszek, curator of photography at the Los Angeles County Museum of Art, compares Annie Leibovitz's complex, staged portraits with those of artist/photographer Cindy Sherman, who takes on different personas for self-portraits. "The difference," he says, "is that Annie Leibovitz photographs her subjects, not herself, in very theatrical situations."[7]

In one interesting photo session, Leibovitz photographed Sherman. Leibovitz was forced to be inventive. She said later:

[Sherman] didn't really want to be photographed at all. She met me at her studio door wearing a white shirt, black pants, no make-up and said she wanted to hide in the picture. So I hired a casting agent to find nine look-alikes: same build, same hair, and put them in a row like an identity parade. No one knows who is the real Cindy Sherman![8]

AN ARTISTIC CHAMELEON
Cindy Sherman, like Lorna Simpson, is concerned with the way women are portrayed in the mass media. Unlike Simpson, however, Sherman often uses gro-

Cindy Sherman in 1960

tesque images to reveal her views on how male-dominated society and popular culture have victimized women throughout history.

Many critics consider Sherman first a performance artist, then a photographer. She came of age during the mid-1970s, when artists staged live performances of dance, music, and art everywhere—not just in museums and galleries. Sherman did not originally plan to become a photographer. In fact, she failed a photography course at the State University of New York at Buffalo because she could not grasp the technique. It took a new teacher to convince her that technique was as important as concept.

Shortly after receiving her degree in painting and photography, Sherman and her artist friends created a unique living/exhibition space in a former ice factory in Buffalo. For several years they lived there and staged performances and shows, but the lure of lower Manhattan proved too strong.

By the end of the 1970s, the neighborhood south of Houston Street in New York, known as SoHo, had come into its own. With cheap rents and spacious lofts, SoHo had become a mecca for artists from all over the world. Almost from the moment Sherman arrived, she found an audience for her work, which has become increasingly creative and controversial.

Early on, Sherman used friends, family, and even strangers in her photographs. She experimented, but nothing really "clicked" with the images. Because other people were too self-conscious, they could not become different personas. For her work, she had to use the most pliable character she knew—herself.

In her self-portraits, Cindy Sherman uses herself as the canvas and her camera as the audience. She is producer, director, costumer, and star. As a child growing up in New Jersey, she had spent many entertaining

hours dressing up in her mother's and older sisters' clothes. But it was not until she found her great-grandmother's clothes that she felt she was really in costume.

..

AT THE MOVIES

Costume effects provided Sherman with her first one-woman show, which was an instant success. Between 1977 and 1980, she created "Untitled Film Stills." The series of eighty black-and-white photographs looked like movie publicity stills and staged scenes of women in imaginary melodramas. The artist was costumed and made up to fit the different roles.

During the time Sherman worked on the project, she supported herself with a receptionist's job at Artists Space. It was one of many alternative spaces in SoHo created by artists who felt that commercial galleries were not receptive enough to contemporary art. Even with this conventional job, Sherman was far from typical: she often showed up for work in a nurse's uniform to greet visitors.

Despite the acclaim that greeted "Untitled Film Stills," Sherman was not satisfied with the work. She felt that the photographs came too close to real movies. She began to look for less conventional forms of beauty, a quest she continues to this day. Creating "History Portraits" in the late 1980s, she re-created Renaissance painting in photography. Realizing that Renaissance artists had chosen not to portray their subjects as anything less than beautiful, she decided to present the unattractive qualities that had been ignored.

These photographs seem like parodies of the art of the period, with Sherman appearing as dozens of people—male or female, fat or thin, beautiful or unappealing. The photographer seems to want to bring fine art down to earth, to allow people to relate to it more

108

easily. Despite differences from "Untitled Film Stills," the New York art community greeted the "History Portraits" with enthusiasm.

The artist works in intense periods of time that last for weeks—and she works alone, with only her parrot for company. She lives with her husband, French video artist Michel Audet, in a loft in TriBeCa (the *tri*angle *be*low *Ca*nal Street) near her SoHo beginnings. The two-room walk-up contains old furniture in one part of the loft and a bed in the studio. Little if anything has changed in her way of life, despite her considerable fame.

TESTING LIMITS

In her more recent work, Cindy Sherman has moved away from herself as model to the use of mannequins. Challenging the limits of photography more than ever, she has created parodies of pornography. One art critic notes that Sherman "does not provide an easy answer to the dilemma: is pornography reactionary or liberating? The dolls are used to acknowledge the allure of the violence, degradation, and dehumanization at the center of the pornographic impulse. . . . She owns up to the dark side of human nature, and presents it as part of our common humanity."[9]

Sherman has commented that her explicit photographs express her feelings about pornography and censorship in the arts. A member of the Women's Action Coalition, Sherman took part in a visual project in which the group projected images with texts onto a side of a parking garage to raise consciousness about such issues as sexual harassment, during Houston's Republican National Convention in 1992.

The artist acknowledges her efforts to make people feel uncomfortable. She also recognizes that her work, combining a desire to shock and to satirize, has been

both critically and commercially successful, appealing to the very public she professes to ignore.

Including Sherman in her list of "Photography's Top 100," Carol Squiers writes:

Her rise to stardom in the 1980s helped move creative photography, previously of second-class status, into the upper-echelon of art world money, visibility, cultural power. She is the only postmodern artist who takes her own pictures . . . [and] continues to challenge the limits of what photography can do.[10]

THE CHANGING FACE OF ART

Nancy Burson is another contemporary photographer who challenges photography's limits through technology. A St. Louis native who studied art in Denver, she became interested in the computer-generated revolution of producing photographs soon after moving to New York in the late 1960s.

In conventional photography, images are created by light passing through a lens to strike a piece of light-sensitive film, which is chemically treated to produce a negative, from which identical positive prints can be made. Digital photography converts the lens-formed images into two-part numerical "codes" which, stored electronically, can be translated back into tonal values and made into a print.

This two-part, or binary, code can also be manipulated to create basic changes in the original photograph's data. Alterations can include anything from simple removal of unwanted details to the creation of entirely synthetic images, with no evidence of alterations or "seams" between its parts.

110

Burson developed the idea of using this computer-generated art to show how a person's face might age over time. In the late 1970s, she worked with scientists from the Massachusetts Institute of Technology on the technique called "computer facial wrapping," which can create artificially aged portraits. In 1981, Burson and scientist Thomas Schneider were granted a patent for this process.

People can use digital imaging to change particular features of a subject's appearance, and to combine features from different people. Nancy Burson created such composite portraits in the early 1980s, including "Big Brother," a twentieth-century villain with the merged faces of Stalin, Hitler, Mussolini, Mao, and Khomeini. Another work was "First and Second Beauty Compositions," which contrasts the ideal look of film stars of the 1950s and 1970s by blending the faces of five stars from each decade into single images.

Nancy Burson produces pictures of ideas, not people; they are visual images that are not real, yet are somehow familiar. The digital process she helped create is now also widely used in print journalism, advertising, and commercial photography. Its use is also practical: police detectives make use of it to trace missing children and track down criminal suspects.

To photography historian Naomi Rosenblum, Burson's technique is "the ultimate visual expression of contemporary media-based culture. The employment of such technologies by artists will undoubtedly bring even greater complexity to future discussions about the relationship between images and reality."[11]

Women photographers are moving into the forefront of the field, using their imaginations, cultural heritage, and technological skills to offer newer, more original visions of what the art can do, pushing its boundaries still farther.

Closing the Aperture

During the sweeping changes in all spheres of life over the past two centuries, women photographers have taken camera in hand to capture the moment and to create their own rendering of life as they saw it. Men and women alike have photographed the large spectacle of wars and famine, and the smaller moments of family and home. As women photographers have recorded the changing scene, one might wonder: is there a uniquely female focus? If so, how have they used it to produce their images? Have they used similar means to create these effects, and how did their styles vary?

While there *is* a female focus in photography, it is as multifaceted as women themselves. Women who have made a name for themselves as photographers at first glance appear quite different one from another, personally and professionally. Some traveled widely, aiming their cameras at the world; others have been content to capture life at home or around the corner. Some were openly independent in personality; others preferred to let the work project their freedom of spirit.

Even the subjects these women chose to photograph varied widely. Dorothea Lange and Margaret Bourke-White felt compelled to document the human suffering around them during the 1930s and 1940s, while Anne Brigman was inspired by the solitary wildness of nature.

Berenice Abbott recorded the changing face of a major city in the 1930s, while at about the same time Barbara Morgan found her graphic interest in the arts. Diane Arbus turned her back on the same fashion world that Louise Dahl-Wolfe found so engaging in the 1950s, and Mary Ellen Mark's "unfamous" subjects stand in sharp relief to Annie Leibovitz's celebrities.

Dramatic differences are particularly apparent in the work of Dorothea Lange and Diane Arbus, both of whom chose to photograph people, albeit a generation apart. Lange delineated the impact of external forces on people's lives; Arbus reached inside her subjects to express the root causes of human behavior. Lange needed to remind us of a world in trouble; Arbus wanted to create a world of her own.

The personal and professional influence of men on women photographers has also varied widely. Dorothy Norman always acknowledged the role of Alfred Stieglitz in her life's work; Imogen Cunningham considered herself most productive as an independent divorced woman.

Some artists working one hundred years ago—Catharine Barnes Ward and Eva Watson-Schütze, among others—were recognized professionals before deciding to marry, and continued along that career path all of their lives. A century later, Cindy Sherman and Mary Ellen Mark and their husbands lead artistically parallel, mutually supportive lives.

Frances Benjamin Johnston and Berenice Abbott chose not to attach themselves to men, while Jeanne Moutoussamy-Ashe considers her late husband a major

force in her career. Even with husbands unconnected to the world of photography, some women photographers enjoyed strong support from the men in their lives.

While there are distinct differences between these artists, closer examination reveals many similarities. A common thread of determination and focused effort began early on and continues. Concerned with the role of women as artists and with their own place in a society, the pioneers set the tone for artistic activism. And long before women had the vote, they were opening their own photography businesses—through necessity or creative desire—and striving for success.

Often women have had to work around constraints of all kinds. Gertrude Käsebier was not the only woman of talent compelled to wait until her children were grown to begin her career. And Dorothea Lange was not the only professional hired as a "clerk" to get around government regulations on a photographic expedition.

Women have historically asked for no special treatment to prove their artistic worth—or their courage under fire. Photographing wars, urban violence, and other scenes of danger and disorder over which they had little or no control, women have sought no quarter.

This courage to forge ahead has been due in no small measure to the strong support women have historically given to each other in this field. From the first women to take up a camera, there has been a continuing tradition of encouragement. Women have served as role models and mentors, colleagues and friends. There has been much generosity and support.

There are countless examples of such connections. Gertrude Käsebier and Frances Benjamin Johnston referred jobs to each other and served together on exhibition juries. Käsebier had a productive association with Alice Boughton and served as an early role model for Imogen Cunningham. Cunningham returned the favor

for Judy Dater and was also friend to Dorothea Lange in San Francisco.

While many women photographers gave assistance to colleagues they had met during their lifetimes, role models have also come from earlier times. Jeanne Moutoussamy-Ashe emphasizes the influence of generations of black women photographers who came before her. Berenice Abbott's urban landscapes of the 1930s echo half a century later in the work of contemporary photographer Barbara Crane. And Barbara Morgan's unique dance images of the 1940s are a legacy for such modern photographers as Lois Greenfield and Ernestine Ruben.

The passion and immediacy found in the best photographs enlarge our vision—of our immediate surroundings and of the world well beyond. We look to the women photographers of the next century, connected to past generations of talented, determined artists, to expand that vision still further.

Source Notes

CHAPTER ONE
1. John Humphrey, introduction to Margery Mann and Anne Noggle, *Women of Photography: An Historical Survey*, (San Fransisco Museum of Modern Art, 1975), p. 1.
2. Anne Tucker, ed., *The Woman's Eye* (New York: Alfred A. Knopf, 1973), p. 1.
3. Constance Bannister, *Popular Photography*, June 1943, p. 38.

CHAPTER TWO
1. Quoted in Naomi Rosenblum, *A History of Women Photographers* (New York: Abbeville Press, 1994), p. 43.
2. Jeanne Moutoussamy-Ashe, *Viewfinders: Black Women Photographers* (New York: Writers & Readers Publishing, 1993), p. 11.
3. Beaumont Newhall, *The History of Photography* (New York: Museum of Modern Art, 1964), p. 89.
4. Moutoussamy-Ashe, p. 22.

5. Quoted in Rosenblum, p. 58.
6. Ibid., p. 98.
7. Quoted in Lee D. Witkin and Barbara London, *The Photograph Collector's Guide* (Boston: New York Graphic Society, 1980), p. 89.

CHAPTER THREE
1. Quoted in brochure for exhibition on Gertrude Käsebier, American Portrait Gallery, Washington, D.C., 1994.
2. Quoted in Witkin and London, p. 172.
3. Quoted in Rosenblum, p. 77.
4. Quoted in Witkin and London, p. 89.

CHAPTER FOUR
1. Imogen Cunningham, *After Ninety* (Seattle: University of Washington Press, 1977), p. 13.
2. Quoted in Cunningham, p. 17.
3. Margaretta Mitchell, introduction to Cunningham, p. 19.
4. Imogen Cunningham, "Photography as a Profession for Women," *The Arrow of Pi Beta Phi*, vol. 29, no. 2 (January 1913), quoted in Cunningham, p. 15.
5. Berenice Abbott, "What the Camera and I See," *Art News*, September 1951, pp. 36–37.
6. Gerritt Henry, "Berenice Abbott," *Art News*, October 1973, p. 74.
7. Quoted in Witkin and London, p. 65.

CHAPTER FIVE
1. Quoted in Milton Meltzer, *Dorothea Lange: A Photographer's Life* (New York: Farrar, Straus & Giroux, 1978), p. 76.
2. Quoted in Meltzer, p. 90.

3. Dorothea Lange, "The Assignment I'll Never Forget: Migrant Mother," *Popular Photography*, February 1960, pp. 42–43, 128.
4. Quoted in Meltzer, pp. 135–136.
5. Quoted in Linda Morris, "A Woman of Our Generation," in *Dorothea Lange: A Visual Life* (Washington, D.C.: Smithsonian Institution Press, 1994), p. 33.
6. Louise Dahl-Wolfe, *A Photographer's Scrapbook* (New York: St. Martin's Press, 1984), p. 85.
7. Ibid., p. 86.
8. Ibid., p. 105.
9. Louise Dahl-Wolfe, "My Favorite Picture," *Popular Photography*, September 1940, p. 19.

..............................

CHAPTER SIX
1. Margaret Bourke-White, *Portrait of Myself*, excerpted in *Written by Herself—Autobiographies of American Women* (New York: Vintage Books, 1992), p. 454.
2. Ibid., p. 456.
3. Ibid.
4. Sean Callahan, *The Photographs of Margaret Bourke-White* (New York: Bonanza Books, 1972), p. 15.
5. Quoted in Meltzer, p. 184.
6. Bourke-White, p. 471.
7. Callahan, p. 177.
8. Edward Sozanski, "The Photographer Who Collected Souls," *Philadelphia Inquirer*, July 17, 1994, p. E-1.
9. Carol Squiers, "Dorothy Norman," *American Photography*, March-April 1993, p. 16.
10. Quoted in Miles Barth, ed., *Intimate Visions: The Photographs of Dorothy Norman* (San Francisco: Chronicle Books, 1993), p. 156.
11. Ibid., p. 24.
12. Interview with author, December 27, 1994.
13. Quoted in Newhall, p. 159.

CHAPTER SEVEN

1. *Documentary Photography*, rev. ed. (Alexandria, Va.: Time-Life Books, 1983), p. 95.
2. Ibid.
3. Quoted in Pat Booth, *Master Photographers* (New York: Clarkson N. Potter, 1983), p. 24.
4. Eve Arnold, interviewed in *Photographic INsight Journal*, 1992, p. 14.
5. Naomi Rosenblum, "Diane Arbus," in *Contemporary Photography* (Chicago: St. Martin's Press, 1982), p. 26.
6. Amy Goldin, "Diane Arbus: Playing with Conventions," *Art in America*, March 1973, p. 73.
7. Rosenblum, "Diane Arbus," p. 26.
8. Quoted in Tucker, p. 113.
9. Quoted in Jonathan Green, *American Photography: A Critical History, 1945–Present* (New York: Harry N. Abrams, 1984), p. 115.
10. Judy Dater, *Imogen Cunningham: A Portrait* (Boston: New York Graphic Society, 1979), p. 17.
11. Tucker, p. 142.

CHAPTER EIGHT

1. Quoted in Constance Sullivan, ed., *The Photo Essay: Photographs by Mary Ellen Mark* (Washington, D.C.: Smithsonian Institution Press, 1990), p. 13.
2. Carol Squiers, "Photography's Top 100," *American Photography*, January-February 1994, p. 72.
3. Interview with author, February 12, 1995.
4. Quoted in Sullivan, p. 15.
5. Interview with author, February 12, 1995.
6. Ibid.
7. "Lives from Off Center," *Esquire*, September 1991, p. 63.
8. Interview with author, October 28, 1994.

9. Ibid.
10. Moutoussamy-Ashe, p. xviii.
11. Ibid.
12. Interview with author, October 28, 1994.
13. Quoted in Steven Jenkins, "A Conversation with Hulleah Tsinhnahjinnie," *Art Week*, May 6, 1993, p. 4.
14. Ibid., p. 5.
15. Ibid.

..

CHAPTER NINE
1. Quoted in Deborah Willis, *Lorna Simpson* (San Francisco: Friends of Photography, 1992), pp. 7–8.
2. Ibid., p. 6.
3. Andy Grundberg, afterword to Willis, p. 62.
4. Quoted in "A Conversation with Ingrid Sischy," in *Annie Leibovitz: Photographs, 1970–1990* (New York: HarperCollins, 1991), p. 8.
5. Ibid., p. 9.
6. Ibid.
7. Quoted in *Art News*, March 1992, p. 93.
8. Quoted in *The Glasgow* (Scotland) *Herald*, July 11, 1994, p. 12.
9. Eleanor Heartney, "Cindy Sherman at Metro Pictures," *Art in America*, September 1992, p. 127.
10. Squiers, "Photography's Top 100," p. 66.
11. Rosenblum, *A History of Women Photographers*, p. 246.

Suggested Reading

BOOKS ABOUT THE HISTORY OF PHOTOGRAPHY

A Woman's Eye: Black and White Photography. Miami, Fla.: Inter-American Art Gallery, Miami-Dade Community College, 1988.

Booth, Pat, ed. *Master Photographers*. New York: Clarkson N. Potter, 1983.

Gover, C. Jane. *The Positive Image: Women Photographers in Turn of the Century America*. Albany: State University of New York, 1988.

Mann, Margery, and Anne Noggle. *Women of Photography: An Historical Survey*. San Francisco Museum of Modern Art, 1975.

Moutoussamy-Ashe, Jeanne. *Viewfinders: Black Women Photographers*. New York: Dodd, Mead, 1986.

Newhall, Beaumont. *The History of Photography*. New York: Museum of Modern Art, 1964.

Pollack, Peter. *The Picture History of Photography*. New York: Harry N. Abrams, 1969.

121

Rosenblum, Naomi. *A History of Women Photographers.* New York: Abbeville Press, 1994.

Sullivan, Constance, ed. *Women Photographers.* New York: Harry N. Abrams, 1990.

Szarkowski, John. *Looking at Photographs.* New York: Museum of Modern Art, 1973.

Tucker, Anne, ed. *The Woman's Eye.* New York: Harry N. Abrams, 1990.

Witkin, Lee, and Barbara London. *The Photograph Collector's Guide.* Boston: New York Graphic Society, 1979.

..

BOOKS ABOUT PHOTOGRAPHERS AND THEIR WORK

Annie Leibovitz Photographs. New York: Pantheon, 1983.

Annie Leibovitz: Photographs 1970–1990. New York: HarperCollins, 1991.

Arbus, Doon, and Marvin Israel, eds. *Diane Arbus: An Aperture Monograph.* Millerton, N.Y.: Aperture, 1972.

Arnold, Eve. *Flashback! The Fifties.* New York: Alfred A. Knopf, 1978.

Barth, Miles, ed. *Intimate Visions: The Photographs of Dorothy Norman.* San Francisco: Chronicle Books, 1993.

Berenice Abbott: Photographs. Washington, D.C.: Smithsonian Institution Press, 1990.

Block, Jean P. *Eva Watson-Schütze: Chicago Photo Secessionist.* University of Chicago Library, 1985.

Bourke-White, Margaret. *Portrait of Myself.* New York: Simon and Schuster, 1963.

Callahan, Sean. *The Photographs of Margaret Bourke-White.* New York: Bonanza Books, 1972.

Cindy Sherman. New York: Whitney Museum of American Art, 1987.

Cunningham, Imogen. *After Ninety.* Seattle: University of Washington Press, 1977.

Dahl-Wolfe, Louise. *Louise Dahl-Wolfe: A Photographer's Scrapbook*. New York: St. Martin's Press, 1984.

Daniel, Pete, and Raymond Smock. *A Talent for Detail: The Photographs of Miss Frances Benjamin Johnston, 1889–1910*. New York: Harmony, 1974.

Dater, Judy. *Imogen Cunningham: A Portrait*. Boston: New York Graphic Society, 1979.

Dater, Judy, and Jack Welpott. *Women and Other Visions*. Dobbs Ferry, N.Y.: Morgan and Morgan, 1975.

Fulton, Marianne. *Mary Ellen Mark: Twenty-Five Years*. Boston: Little, Brown, 1991.

Homer, William Innes. *A Pictorial Heritage: The Photographs of Gertrude Käsebier*. Wilmington: Delaware Art Museum, 1979.

Krauss, Rosalind. *Cindy Sherman, 1979–1993*. New York: Rizzoli, 1993.

Meltzer, Milton. *Dorothea Lange: A Photographer's Life*. New York: Farrar, Straus & Giroux, 1978.

Michaels, Barbara L. *Gertrude Käsebier: The Photographer and Her Photographs*. New York: Harry N. Abrams, 1992.

Morgan, Barbara. *Sixteen Dances in Photographs*. Dobbs Ferry, N.Y.: Morgan and Morgan, 1980.

Palmquist, Peter E. *Catharine Weed Barnes Ward: Pioneer Advocate for Women in Photography*. Arcata, Calif.: Peter E. Palmquist, 1992.

Partridge, Elizabeth, ed. *Dorothea Lange: A Visual Life*. Washington, D.C.: Smithsonian Institution Press, 1994.

Sullivan, Constance. *The Photo Essay: Photographs by Mary Ellen Mark*. Washington, D.C.: Smithsonian Institution Press, 1990.

Willis, Deborah. *Lorna Simpson*. San Francisco: The Friends of Photography, 1992.

Index